Natural Reality and Abstract Reality

An Essay in Trialogue Form

Natural Reality and Abstract Reality

An Essay in Trialogue Form

by Piet Mondrian

Translation and Introduction
by Martin S. James

GEORGE BRAZILLER NEW YORK

Published in the United States in 1995 by George Braziller, Inc.

"Introduction," "A Note on Mondrian's Terminology," "Two Urban Sketches," "Chronology," "Bibliography," and English translation of "Natural Reality and Abstract Reality," by Martin S. James Copyright © 1994 by George Braziller, Inc.

"Les Grands Boulevards" and "Little Restaurant—Palm Sunday" Copyright © 1986 by Harry Holtzman. Reprinted with the permission of the Estate of Harry Holtzman.

For information, please address the publisher:
George Braziller, Inc.
60 Madison Avenue
New York, New York 10010

Library of Congress Cataloging-in-Publication Data:

Mondrian, Piet, 1872-1944.
 Natural reality and abstract reality : an essay in trialogue form
 (1919-1920) / Piet Mondrian.
 p. cm.
 Published in Dutch in [the periodical] *De Stijl*
 in twelve installments, from June 1919 through July 1920.
 ISBN 0-8076-1371-1 (cloth)
 ISBN 0-8076-1372-X (pbk.)
 1. Naturalism in art. 2. Painting, Abstract.
 I. Mondrian, Piet, 1872-1944. New art—the new life. II. Title.
 ND1482.R4M66 1995 94-38785
 700—dc20 CIP

Printed and bound at Haddon Craftsmen, Scranton, Pennsylvania.

Designed by Lundquist Design, New York.

First printing.

CONTENTS

INTRODUCTION

Mondrian to 1919

Piet Mondrian died in New York in 1944 at the age of 72, after a long artistic career begun in Amsterdam in the 1890s and continued in Paris and London. While still far from his current fame, he was admired in concerned circles as the leading exponent of "pure" abstract painting.

Had his life ended in 1919, at the time his *Trialogue* appeared in print, he could never have created the styles universally associated with his name: his "classic" Neo-Plasticism of the 20's and 30's with rectangular planes of primary color with black lines on white, or the familiar "Boogie-Woogie" paintings of his last years.

Yet even shortened by a quarter-century, Mondrian's accomplishments prior to 1920 would surely have earned him a place in modernist history alongside such pioneers of non-representationalism as Kandinsky, Malevich, or Kupka. By the time in question Mondrian had not only evolved a uniquely clear and consistent abstract expression, but had also established its theoretical underpinnings.

It was largely on this dual foundation that the artist-critic Theo van Doesburg in 1917 brought out his monthly periodical *De Stijl*, aimed at collaborative integration of the arts, in the interest of a higher life that would combine

modernity with universal spirituality. On the threshold of the 20's, the painting, architecture, and sculpture of *De Stijl* stood ready to play its influential role on the international scene.

Meanwhile in Holland (van Doesburg would recall) "we were treated as outlaws and pariahs . . . each new demonstration, exhibition, lecture bringing down on us the wrath of the bourgeois press." Nevertheless, over the decade 1909–19, Mondrian was conspicuous in the Dutch art world as the most radical representative of its avant-garde.

Over the years, a few friends and patrons able to accept the loss of particular subject-matter, discerned the extraordinary painterliness of his art, its rich content, its near-religious profundity. By 1920, the major collections of his oeuvre to date were already formed; in the Dutch museums of today, they thoroughly document the first half of a brilliant career.

<p style="text-align:center">* * *</p>

Born, as it were, into the profession of art, Mondrian was from childhood initiated in representational skills by his father, an orthodox Calvinist school principal who also designed ideological prints, and his uncle, a professional painter of landscapes in the Barbizon/impressionist manner known as the "Hague School." After further training at the

Amsterdam academy in the early 1890's the young artist set out on a mainstream career: portrait and other commissions, still-lives, and rural landscapes in the quiet Hague manner, characterized by precise observation of atmosphere and fidelity to local "mood." Even in his abstract period Mondrian remained a keen observer. "Nothing escaped his eye," reported a friend of his last years.[1]

Painting for the market did not exclude private experimentation. Some years after the turn of the century, Mondrian's sensibility acquired a more subjective tinge: his "Evening Landscape" series of 1906–07, with somber tree-masses mirrored by moonlight in glinting waters, married verisimilitude to symbolist feeling, carried by broader brush-work and expressive color (Cf. *Trialogue* scenes 1 and 2.)

A definitive turning point occurred in 1908–09 when Mondrian, with a few fellow "luminists," adopted fauvist and divisionist techniques, with their inherently anti-illusionist character. For Mondrian, these freer methods implied a dematerialization of "things," a distancing from everyday nature.

Spiritual yearnings of this order lay at the heart of the Theosophical movement, which Mondrian officially joined in 1909. Theosophists sought clear consciousness of the reality hidden from ordinary vision. Like other forms of occultism (occult = hidden) popular among artists and literati of the fin-de-siècle, Theosophy offered Platonically exact truths to those left at sea by nineteenth-century

9

materialism. "Clarity of thought," Mondrian wrote at the time, "should be accompanied by clarity of technique."

Soon he found more exact plastic means: a geometric stylization in terms of triangulated planes, sometimes described as "proto-cubist." Once again, hues were "exaggerated" for evocative and symbolic purposes. This sublime style was well-suited to convey a sense of the monumental—of the supra-human and ideal—contained in the isolated windmill subject or frontally seen church. (cf. *Trialogue*, Scenes 4–6). (Mondrian conceived the triptych *Evolution*, 1910–11, in the same hieratic spirit, though he would soon reject reliance on symbols possessing with specific, "limited" meaning (cf. *Trialogue*, scene 4).

The next turning point was occasioned by Mondrian's discovery of cubist painting in a 1911 exhibition he had helped organize. Following the new vision to its source, he soon left for Paris (early 1912). The city's dynamic and cosmopolitan character enthralled him (cf. *Trialogue* scene 7; also *Les Grands Boulevards*). Except for a wartime hiatus (1914–19) he would remain there until the threat of a new war drove him to London in 1937.

It was the cubists' annihilation of the closed object, Mondrian repeatedly noted, that opened the way to more radical abstraction. In his own adaptation of cubist painting (notably the highly structural "compositions" of 1913–14, extrapolated from studies of trees) he already accentuates horizontal-vertical relationships. (At the spring 1913 Salon

des Indépendants, the poet Guillaume Apollinaire noted the "very abstract cubism" of Mondrian and its "sensitive intellectuality").

Mondrian's continued "tautening" of the linear elements produced definitely straight or curved segments, which he opposed rhythmically among themselves, as well as to well-defined color planes, such as in his Compositions of 1913–14, which are abstracted from studies of exposed side walls.

During his enforced wartime stay in Holland from 1914 to 1919, Mondrian at first worked exclusively in terms of straight line segments in multiple horizontal-vertical oppositions, against a light ground (this was his "plus-minus" phase of 1913–15). Although based—as was hitherto Mondrian's invariable habit—on studies from nature (church façades, sea and jetty, sky and ocean), these motifs became generalized to the point of losing all specificity. Particularity yielded to the universal.

The next step (1916–17) was to broaden the drawn line segments into hard-edged rectangular color planes suspended before a white ground—anticipating in some respects the look of "classic" Neo-plasticism.

As always with Mondrian, solving one challenge only gave rise to another—in this case the weak relationship of the sharply determined planes and the indefinite white "background."

How, then to combine overall unity or regularity (the

universal) with a degree of irregularity or contingency? In 1918–19 Mondrian sought the answer in variations of the grid or lattice (the constant element), within which were distributed relatively random accents (the variable). Certain of these lattice compositions were associated with the starry sky exemplifying multiple relationships in the *Trialogue* (scene 2).

Among possible grid formats, one suggested perfect unity and regularity: the square, which when rotated by 45 degrees, became the "diamond." The diamond was a distinctive invention of Mondrian's who down to his last canvas, *Victory Boogie-Woogie*, exploited its potential in creative ways.

The made space of the grid has preoccupied artists throughout the century: Mondrian's series of 1918–19 anticipates the minimalist and systemic art of several decades later.[2]

No less innovative was Mondrian's abolition of the traditional picture frame. The expression of relationship, he held, required the flatness of painting ("the plane in the plane"). The window-like opening of the frame, on the other hand, inevitably strengthened the illusion of depth. "So far as I know, I was [in 1916] the first to bring the painting forward from the frame rather than set it within the frame."[3]

From the grid paintings Mondrian passed, through a series of subtle changes, to his "classic" phase of the next decade—which, in turn, he would continue to evolve towards greater openness, dynamism, and freedom.

The Dialogue and Trialogue

Mondrian's treatise on the nature and theory of "Abstract-Real" art, *The New Plastic in Painting*, was serialized in *De Stijl* over the first year of its publication (October 1917–December 1918). In its later sections the essay had become bewilderingly abstract and metaphysical. It was perhaps as an antidote that Mondrian turned to the conversational form in his *Dialogue on the New Plastic* and trialogue *Natural and Abstract Reality* that followed upon its heels, appearing in the periodical between February 1919 and August 1920. The first piece was written in Holland, the second mainly in Paris, where Mondrian returned in mid-1919.

The discussions reflect conversations with friends and colleagues held over many years, as well as preserved letters to reviewers—not so much the hostile ones presumably targeted by his remark "writers are the worst criminals" as the well-disposed who had difficulty following his continuous shift to the abstract, or failed to comprehend his aims as precisely as he would have liked.

Almost a century later we easily overlook the anxiety aroused by an art robbed of subject-matter. Hence the questioners' analogies between the new expression and music or the extra-sensory, not to mention the by now familiar allegations of impersonality and monotony. Hence too the abstract-real artist's counter-claim that the new plastic constitutes *the* style to end all styles, since it contains in essence what

all art of all the ages sought to express—relationship, repose, harmony, life force . . . the universal.

<p style="text-align:center">* * *</p>

The *Trialogue's* subtitle, "While Strolling from the Country to the City," already suggests settings of growing abstractness.

We first learn (scene 1) that relationships exist in nature, more or less discernable according to locale and our own ability to see. The next scenes show first the disturbing randomness of organic nature (scene 2), then a clear cut panorama, where natural structure is more in evidence (scene 3). Next come things shaped by man and manifesting the human spirit: the garden, windmill, and church of scenes 4, 5, and 6. Finally, relationship appears "determinately" in the bright studio of the abstract-real painter.

On one level the progression serves to illustrate Evolution in the theosophical sense: spirit growing into better equilibrium with matter (nature). The seven scenes may refer to the occultists' seven planes of being.[4] Such evolution is inseparable from the growth of consciousness, which is also to say the evolution of vision—which in its deeper, therefore more precise or "determinate," form Mondrian calls esthetic or "plastic vision."

At the same time, the successive settings roughly correspond to the subjects that typically formed

Mondrian's starting points over the two past decades—the woods of the Evening Landscapes series (scenes 1 and 2); the hieratic windmill or church (scenes 4 to 6); the generalized evocation of sea and starry sky in his abstractions of 1914–19.

The last and longest scene, 7, leaves the world of nature for the built environment. It is exceptionally interesting for what it tells of the otherwise undocumented first Neo-plastic interior: the rue de Coulmiers studio, which Mondrian took over in late 1919, and articulated spatially by means of bold color planes affixed to the walls.

In explaining this milieu to his friends, the abstract-real painter expounds his holistic conception: the isolated canvas should not exist for its own sake; it should be seen (if not painted!) in relation to the entire interior. Each of Mondrian's later studios would be treated in comparable manner: he often described his painting as "preparation for future architecture."

The same pure and self-neutralizing relationships, Mondrian's surrogate continues, must be extended to the outdoor spaces of city, for the modern metropolis is the true home of the new and complete man, man thoroughly oriented to the abstract. In the distant future, the separate "work of art" will dwindle away, absorbed into the new life of "equivalent relationships."

For Mondrian the idea of equivalence was no mere metaphor for beauty and harmony. A neo-plastic picture

was for him a living paradigm for what life should be, on individual, social, and international levels.

He knew with inspired certainty that the writing to which he devoted so much of his effort contained, like his painting, a crucial message for the future of mankind.

1 Carl Holty, verbally to the present writer.

2 J. Joosten, "Abstraction and Compositional Innovation," *Artforum*, April 1973, 57; Rosalind Krauss, "Grids," in *The Originality of the Avant-Garde and Other Modernist Myths*, MIT Press, Cambridge 1985, 8–12.

3 "An interview with Mondrian [1943]," *The New Art—The New Life: The Collected Writings of Piet Mondrian*, ed. Harry Holtzman and Martin James, G.K. Hall, Boston 1986, 385.

4 Carel Blotkamp, *Mondrian: The Art of Destruction*, Reaktion Books, London 1994, 140.

A Note on Mondrian's Terminology

Mondrian's idealist thought may at times be hard for the modern reader to follow. Thus, his diffuse dualism of inward/outward overlaps, but is not identical with the opposition spiritual/material; and the related term "interiorizing" might translate, according to context, as "spiritualizing," "de-materializing," "subjectivizing," "deepening," "abstracting," or "sublimating." His later writings become more down-to-earth in their language.

More fundamental was his concept of "(the) plastic." In 1917 he alternatively designated Abstract Real art as "De Nieuwe Beelding," "(The New Plastic)." The Dutch word "beeld" ("image" or "picture") gives rise to "beelden" ("to represent"); "beelding" ("representation"); and "beeldende kunst" ("plastic art").

"Plastic," Mondrian would later note, "means simply that which creates an image." This image, of course, was by no means the picture replicated by "ordinary" vision, but rather the more abstract representation of pure structure, which esthetic contemplation discerns through the veil of "appearances."

Strictly speaking, our use of "Neo-Plastic" and "Neo-Plasticism" in the text of the *Trialogue* is a trifle premature: these non-Germanic equivalents came into being only at the turn of 1920-21, in Mondrian's pamphlet *Le Neo-Plasticisme*. More strongly than its Dutch counterpart, "plastic" (from the Greek "plassein," "to shape," "to mould"), it carries connotations of formativeness and seminality.

Mondrian's metaphysic was chiefly inspired by Helena P. Blavatsky's Theosophy, a late nineteenth-century

synthesis of Neo-platonic and Hindu/Buddhist teachings, and to a lesser extent by the Anthroposophy of her former disciple Rudolf Steiner, who brought occultism into the esthetic sphere. Mondrian's conception of the modern spirit in process of realization furthermore reflected Hegel's dialectical philosophy of spirit—as popularized with remarkable success in the first decade of our century by the Romantic thinker's Dutch follower, Professor G.J.P.J. Bolland.

Common to such world schemata was first the conception of levels of reality, rising ladder-like from the material and physical to the abstract and active life-principle, spirit. Second, there was the belief in individual or collective ascent to these higher levels—progressive evolution toward a clearer consciousness of, and ultimate merging with, spirit, or the universal.

Mondrian's concepts are nevertheless easily grasped. The spirit-matter dichotomy, creating the need to restore equilibrium and unity between the two elements, engenders an ongoing series of oppositions, which can be listed (in no set order) as:

SPIRIT	Universal	Abstract	Force	Inward	Active
MATTER	Particular Individual	Concrete Real	Appearance	Outward	Passive
SPIRIT	Male	Progressive	Vertical	Truth . . . and so on	
MATTER	Female	Conservative	Horizontal	Beauty . . . and so on	

Mondrian's dualistic outlook served as a crucially important structuring principle for his art and theory.

—Martin S. James

Natural Reality and Abstract Reality
An Essay in Trialogue Form

A trialogue (while strolling from the country to the city) among X, a naturalistic painter; and Y, a layman; and Z, an abstract-real painter.

First Scene. Late evening—flat land—broad horizon—high above it the moon.

 Y. It's so beautiful.

 X. What depth of tone and color!

 Z. Such peace!

 Y. So nature moves you too?

 Z. If it didn't, I wouldn't be a painter.

 Y. Since you no longer depict nature, I thought nature no longer meant anything to you.

 Z. On the contrary. Nature moves me deeply. I just paint it differently.

 X. I sometimes call your compositions "symphonies." I can see music in them, but nature . . . no.

 Z. Music can just as well be discerned in naturalistic painting. Naturalistic painting, too, has its *rhythm,* even if it not as noticeable as in abstract-real painting.

X. Yes, but abstract-real painting communicates *without form;* and it has this in common with music, that music too does not employ naturalistic means.

Z. I cannot agree. Combinations of sound— at least those of traditional music—also express *form;* which, even if it cannot be *seen,* can certainly be *heard.* The auditory can be very naturalistic indeed, as traditional music clearly shows. I nevertheless see a similarity between abstract-real painting and *modern* musical compositions which do away with melody, which is to say form. But I don't think that's what you had in mind. You would like to distinguish abstract-real painting from naturalistic painting. But the distinction cannot be such as to place either beyond the limits of painting. No matter how different their *appearance,* the two expressions are not essentially different. Let us go back to the source of the work of art: *the emotion of beauty.* Didn't we share the same emotion a moment ago? You will remember our exclamations in front of this landscape? Y was talking about its *beauty,* you about its *color* and *tone,* while I was speaking of the repose evoked by that beauty of color and tone.

Y. I gladly agree with you there, but . . .

X. But we see so little of that agreement in our art!

Z. That is only superficial. You *emphasize* the tone and the color, I put the emphasis on the outcome; repose; but we all *contemplate the same thing.* That

repose *appears* plastically through the *harmony of relationships,* so indeed I emphasize the *expression of relationships.* Yet your expression of color and tone is equally an *expression of relationship.* You express relationships as I do, and I express color as you do.

> **Y.** Relationships?

> **Z.** Plastic expression takes place through oppositions of color and line, and this opposition is *relationship.*

> **X.** But in painting don't relationships have to be expressed through nature?

> **Z.** On the contrary: the more the natural is abstracted, the more pronounced is the expression of relationship. The new painting demonstrated this and finally came to express *relationships* exclusively.

> **X.** Nature leads me to express relationship spontaneously, but I have little desire to express relationship exclusively. To continue with this landscape, for instance: I do see the relationships between the bright moon, the sky, and the land; I also see that the position of the moon in the landscape is a question of relationship. But I don't understand why, I should have to abstract everything for the sake of these relationships; for me it is precisely the natural that makes the relationship come *alive!*

> **Z.** That depends on one's conception. For me relationship is precisely more alive when it is *not* veiled

by the natural but manifest itself in the flat and the straight. For me, that is a far more intense expression than are natural form and color. Natural appearances generally *veil* the expression of relationship. Therefore if relationship is to be expressed determinately a more *exact* expression of relationship is needed. Ordinary vision cannot here discern the *relationship of position* in a determinate way.

 Y. What do you mean by *relationship of position?*

 Z. The relationship, not so much of dimensions and planes, as of their *position* with regard to one another. The most perfect expression of this relationship is the perpendicular, which expresses the relationship of two opposites.

 In this landscape, the horizontal—with regard to ourselves—is determinately expressed only in the horizontal of the skyline. Thus only one position is expressed determinately: its *opposition,* however, whether as *vertical* or any other position, is not here determinately expressed, as a *line.* Elevation is here expressed as a *plane.* The sky appears as an indeterminate plane, on which the moon, however, manifests itself as a point, therefore *exactly.* The plane is also determined *from this dot to the horizon:* this determination is a *vertical line.* Although the latter does not appear in nature, it is nevertheless there. Were we to draw it, it would represent a determinate opposition to the horizontal. And in this way we see that the relationship of

position, though not exact, is nevertheless plastically manifested in nature. And it is the equilibrated relationship of position—the rectangular contraposition of lines and planes—that plastically manifests repose.

> **Y.** Indeed, the rectangular position is immutable and must therefore express repose.

> **Z.** There is so much repose in this landscape because in it the horizontal and the vertical appear plastically. The positional relationship, although not *purely equilibrated,* appears in *natural harmony.* The brightness of the sky emphasizes the vertical; the veiled horizon, the horizontal. The oblique is excluded, although we would certainly feel it if some object or other were accentuated. If, for instance, a tree rose above the horizon, we would involuntarily draw a line from that tree to the moon: this oblique would oppose the horizontal and vertical in an unequilibrated way, and the *great* sense of repose would be broken.

> **X.** The relationship *of dimension* is also important; it is directly linked to the relationship of position.

> **Z.** Of course, the relationship of position cannot express equilibrium without equilibrated relationship of dimension. And it is this equilibrated relationship of dimensions that also contributes to the landscape's repose.

> **X.** And the relationship of color?

> **Z.** The interaction of color as color and color

as light-and-dark are prerequisites for equilibrium, and yet both color relationship and dimensional relationship are sustained by that of position.

Y. Color in *itself* always affects me so strongly. To me, a single yellow, a simple blue, unfolds a whole world of beauty!

Z. Of course. Color as color enlivens every-thing, and color purely seen can elevate us to the sublime, the universal. But . . . color as such expresses the outward so dominantly that we run the risk of remaining with the outward and vague, instead of *seeing* the abstract.

X. Yet color gains its value only through opposition to another color, through color relationship, as you rightly noted.

Z. This relationship determines the color and removes the vagueness I was speaking of. But this does not contradict what you just said. Thus a red moon would have a quite different expression than the silver-yellow one we are now looking at.

Y. I find a red moon terribly tragic!

Z. This is due not to the color alone but also to the fact that such a moon usually lies closer to the hori-zon; then the horizontal line of the skyline dominates the vertical distance between it and the moon. Thus again the dimensional relationship supports the expression of color. But we must not forget that the color of the sky around the red of the moon also has expressive value: the blue opposes

the red and thus considerably reduces the tragic. Besides, the more we see the *relationships* of colors rather than *color itself,* the more we will be *free of the particular and consequently of tragic expression.*

Y. As I listen to you both speaking of *relationship,* a vague feeling I had is becoming clearer: we should see the visible *as a whole,* a whole that leaves nothing out, and of which all things are indispensable parts. And I can see now that expression of the visible depends on the *placement* of these parts.

Z. Yes, all things are *parts* of the whole: each part receives its visual value from the whole, and the whole from the parts. Everything is expressed through *relationship.* One color exists only through *another,* dimension through *another* dimension, and position only through *another* position opposing it. That's why I call relationship primordial.

Y. Yet when I contemplate the moon, for instance, simply for its own sake, it is already so beautiful in color and form!

Z. Certainly, everything contemplated for its own sake is beautiful, but this is a *limited* kind of beauty. Seeing something by itself we separate it from the whole: oppositions escapes us—we no longer see relationship but only color and form. We observe a color, a form; we think we know these, but no matter how closed the form, or how deep the color, our knowledge is a limited one. And

if we see the things as particularities, as separate, we drift into vagueness and uncertainty and all kinds of imaginings. *One thing can be known only through another,* all wisdom has taught.

Y. But suppose we see only one thing; how will we know it if the other thing is not there?

Z. Just as a whole is one thing plus the other, that is, duality, so it is with any single thing. The one only *seems* one to us; in fact it is a duality, a whole. Each thing contains the whole in miniature. As the sages say, the microcosm is also the macrocosm. So we need only to view each separate thing, *the one,* as a *duality* or *multiplicity*—as a *complex.* And, conversely, to see each thing as *part* of that complex: *a whole.* Then we will always see *relationship,* then we will always know the one through the other.

X. Yes, the one only appears as the one. It is part of a whole, and at the same time a whole of parts . . . this comes to the fore in painting of every kind.

Y. Is no stability to be found amid all these relationships?

Z. There is one permanent relationship among all these changing ones; it is expressed as the perpendicular position, which plastically affords stability.

Y. Is that why you spoke of the perpendicular position when we were discussing the repose of this landscape?

Z. Plastically, its repose derives from this position. Especially, now that it has grown so dark that the details have faded and everything is so flattened; the landscape affects us deeply thanks to this relationship. Visually we see only the horizon . . . and the moon. But abstractly we see the implied vertical: the primordial relationship is manifested. It manifests itself, however, as an entity. That is the *expression of nature,* that can never be the *expression* of art. We humans must still represent repose through *movement,* unity through multiplicity. Always, in painting, the *rhythm* of color and line communicates the feeling of *reality.* The primordial relationship is already a living reality in itself, but it becomes such for *us* only through *relativization,* that is, through multiplicity.

Scene 2. Capricious clusters of trees are silhouetted against the bright, moonlit sky.

> **Y.** How capricious!
>
> **X.** What a majestic sight!
>
> **Z.** Indeed . . . capricious and majestic at once! These grand contours clearly reveal the capriciousness *of* nature.
>
> **Y.** I make out all sorts of heads and figures.
>
> **Z.** Now one clearly perceives the relativity of all appearance in form: everything is far different to us now than it was in daylight.

Y. Perhaps it is because we can no longer discern the details. . . . But actually what is it that makes everything seem so *impressive?*

X. First, as you noted, the coalescence of details. This should be a lesson to us painters; in painting, the great problem is always to keep the details subordinate to the whole.

Y. But I don't see any details!

X. It only seems that way. Movement, color and form are still there, but all is *dominated* by the overall contours.

Z. The encompassing contour does play an important role here. Additionally the light, especially when as strong as it is now, makes all relationships optically *different.* Consequently, when we make relationships photographically true to nature without paying attention to the changes in form and color due to illumination, we will not experience the esthetic emotion elicited by complete reality.

X. In that sense I agree with you that in art we have to transform nature.

Z. A more profound transformation of nature is only one conclusion. But to return to our trees: they also appear so big to us because we see them flattened out.

Y. But I thought that it was a virtue of painting to suggest the volume of things.

Z. That is but relatively true: naturalistic painting does try to create the *illusion* of

volume, but actually it uses the plane.

X. Yes, all the great masters kept their modeling relatively flat within the broad contours.

Z. And modern artists were already becoming more *conscious* of the fact that painting *demands* the plane.

X. But exaggeration can lead us into *decorative* painting!

Z. Painting will by no means become decorative or ornamental art—what is usually thought of as decorative painting. Certain old Byzantine mosaics and ancient Chinese works, for instance, while flat, are not decorative in this sense. What strikes us is their great *inwardness.* All around us we observe that naturalistic plasticity, naturalistic modeling, corporeality, causes us to see things materialistically, so to speak, whereas their appearance in the plane strikes us as so much more inward. The *new* painting became convinced that in painting all modeling *materializes . . .* You may find this conviction extreme, but it has only become stronger.

X. There are extremes in everything! But in principal, I agree. Yet is the plane actually necessary? If the broad contour governs everything, doesn't it annihilate the modelling?

Z. Only to a degree. But since you dislike extremes, let us return to the broad contour. Let us first see what painting did with it. Did painting express that con-

tour according to common vision?

X. No. All the great masters *intensified* it.

Z. In other words, they exaggerated it with regard to ordinary vision.

X. Does the painter, then, never represent things according to *normal* vision?

Z. We must assume that he *transforms* it . . . so we agree in principal. But then you must allow a more *thorough going change,* namely the *most complete tension of line,* which is to say complete *straightness.*

Y. That too is an *extreme!* According to the New Plastic this is what the plane and the straight line must do.

Z. The planar and the straight are only *means* . . . the doing is up to the artist.

X. We agree on that, but for myself, I'd rather follow nature!

Z. In that case you must also accept the capricious in nature.

X. The fantastic is beautiful.

Z. Beautiful but tragic; if you follow nature you will only in small measure abolish the tragic in your art.

Naturalistic painting can make us *feel* the harmony that transcends the tragic, but it cannot *express* it determinately, since it does not express equilibrated *relationships* exclusively. Natural appearance, natural form, natural color, natural rhythm, even in most cases natural

relationships, are plastic expressions of the *tragic.*

Y. When I compare this landscape to the previous one, without these capricious trees, I indeed feel that capricious natural form cannot produce in us that great sense of repose to which we inwardly aspire.

Z. Yes, these trees demonstrate that tensing of contours and flattening of volume cannot give that great repose its *direct plastic expression.* You were quite right to say that repose is more strongly manifested in that treeless landscape.

Y. There I could at least *feel* that repose.

Z. And if you recall what I said about the plane, the straight, and especially about *relationship,* it will also become clear to you *how* and to what degree that great repose can be *plastically manifested.*

Y. That is true . . . *natural appearances* were quite secondary—there was no volume. Everything was flat or straight and, as you said, the *invariant relationship* asserted itself. Must we then always look *past* the natural, in order to consciously contemplate repose?

Z. We need not look past the natural, but we should in a sense look *through* it: we must look deeper, we must perceive *abstractly* and especially *universally.* Then we will perceive the natural as pure relationship. Then external reality will become for us what it actually is: the reflection of truth. For this it is necessary for us to become free of *attachment* to the external: only then do we rise

above the tragic and consciously contemplate repose, in *all* things.

X. Even in the capricious?

Z. Even in the capricious. But then we will no longer be representing it: we will be representing only equilibrated relationship.

Y. Then how significant can be our personal outlook be in the face of the always capricious, therefore tragic character of nature? True, with more profound vision we do not abolish cosmic tragedy; but if we see man as part of the natural, then alleviation of the tragic in each individual and in all of us together can mark the beginning of this abolition.

Y. So through its constantly changing aspects, nature does in the end lead us to a more profound vision?

Z. Yes. Nature, the most external, brings us to consciousness of our *being,* of what in us is most inward. So too in art: it was not human, or individual, thinking or feeling, but concentration on nature itself that led painting to a *purer expression,* to a more immutable expression of beauty. Nature leads us to contemplation, to a merging with the universal, in a sense to greater *objectivity.* Individual thinking and feeling, the human will, particular desires—all *attachment*—result in tragic plastic, preventing any *pure* plastic expression of repose.

Scene 3. Night. Now the stars shine in a bright sky above a wide expanse of sand.

> **Y.** What serenity! Here again is the quiet repose we felt earlier when we saw only the moon and landscape, without those capricious trees.

>> **Z.** We are now, I think, contemplating a yet more complete expression of repose, both in form and in color.

>> **X.** Yes. The color of the sand, for instance, affects us quite differently.

> **Z.** Also, the green countryside of a while ago gave us a feeling of fullness and richness, but the cool sand plastically expresses a still deeper beauty. I meant that the *stars* have now become so much more significant.

>> **Y.** Yes, they are so harmoniously distributed!

>> **Z.** Plastically, they fill the space: they determine it and so bring out *relationship.*

>> **X.** In any case, we are now far from all human triviality.

> **Z.** Now we *see* that another "reality" exists beyond petty human activity. We clearly see how small all that is; all separateness has disappeared. We see a single *whole;* and in contrast to *changeable* human *will,* we contemplate *the immutable.*

>> **Y.** You, at least, do so. I envy your *contemplation.* I cannot yet truly *contemplate,* but I do feel beauty, even if still vaguely.

Z. Contemplation, or plastic vision, is indeed of great importance; the more it helps us to consciously perceive the immutable, the universal, the more insignificant becomes the inconstancy, the individualism, all that is pettily human in and outside of us. Esthetic *contemplation,* in fact affords mankind a means of uniting with the universal in an *abstract,* that is to say, *conscious* way. All contemplation—disinterested contemplation, as Schopenhauer calls it—raises man above his natural state. In accordance with his state, he does everything he can to maintain his individuality. Even his spiritual aspirations fail to serve the universal—which he is incapable of knowing. But in the esthetic moment of contemplation the individual as such falls away. The universal that comes to the face, rendered plastically perceptible through color and line, has formed the essential of all painting. And if the painting of the future is characterized by its plastic determination of the universal, thus becoming free of natural appearances, then this is to be seen as the action of the new spirit of the age which, as it becomes more conscious, will become more able to resolve the separate *moments* of contemplation into a single *moment,* into *permanent contemplation.*

> **Y.** That strikes me as ideal: life would then become constant happiness!
>
> **Z.** Which, abstractly, it is.
>
> **Y.** But really?
>
> **Z.** Isn't the abstract real—if only we can con-

template it?

Y. Although I do not yet truly contemplate the universal, I am beginning to see that if the universal manifests itself plastically, then it must also be real!

> **Z.** Because its manifestation in nature is so *veiled,* it is difficult for us, who are so *naturalistic,* to recognize it.

Y. You said the universal is plastically manifested as the *immutable in terms of relationship, based upon the perpendicular relationship.* I learned to perceive that primordial relationship in the landscape with only the moon and horizon—but what about the present landscape? Is the primordial relationship still present in this starry sky?

Z. I will try to show you that it is still present and in fact becomes *clearer* to us, precisely because of the multitude of stars. Now it reveals itself as *multiplicity:* We no longer have to merely *think* of it as multiplicity: it is now *visible* as such. In this way the universal is determinately manifested. The unique relationship that we could only see determinately in relation to one point, the moon, is now abolished as an entity. For we now have as many definite points in the indefinite plane of the sky as there are stars, and as many relationships are established.

> **Y.** So I should apply to the stars what you told me with regard to the moon?
>
> **Z.** Exactly. Because the stars are determi-

nate points of light, as was the moon. Moreover the stars have the advantage of manifesting themselves as *points* and not, like the moon, as form. In this way the profusion of stars engenders a more *complete* expression of relationship. As I already said, the primordial relationship must be expressed in multiplicity if we are to experience it as a vital reality. To express the primordial relationship in the form of a solitary horizontal and a solitary upright would of course, not be art but at best a *symbol.* Besides, the primordial relationship presented in isolation would express, at least for us men, an entity largely *determined, by ourselves*— whereas the New Plastic aims precisely to avoid expressing anything that is individually determined. To purely experience or contemplate the universal, any self-contained entity must be excluded. That is why the New Plastic must continually interrupt the expression of primordial relationship in the same way as in the star-filled sky one relationship is neutralized by another. That is why this sky so strongly expresses harmony—even more strongly than does the moonlit sky. Multiplicity also engenders *rhythm,* which for us humans is the *plastic expression of life.* As I am sure X will agree, rhythm *merges all particularity into unity.* Plurality of particulars, however, forms a *naturalistic* rhythm that to some extent destroys *the capriciousness of things*—whereas plurality of the primordial relationship forms a more *inward* rhythm, which destroys its absoluteness. This difference points up the breach between the old

plastic and the new: the task of naturalistic painting was to *emphasize* a work's *rhythm,* whereas the new art seeks so far as possible to *abolish natural rhythm.* In the New Plastic, rhythm, no matter how inward, is always present, and is even varied by the diversity of dimensions through which the primordial relationship, that of position, is expressed. And this makes it a *living reality for us humans.*

Y. I think X will understand the question of rhythm better than I. For myself, I have always thought a starry sky more beautiful than one dominated by a moon. The stars appear as points of light. . . . could it be that a point, having no form, succeeds in freeing us from the limitation that form always brings with it?

Z. Because the stars appear as points, they tell *less of themselves and more of the primordial relationship*—at least if we can perceive abstractly. But in ordinary vision the isolated star appears merely as a luminous point; in itself it expresses nothing. It does not free us from limitation since it says nothing determinately about the universal. In ordinary vision the point does not express relationship and so cannot annihilate our individuality. And it is precisely this individuality that is forever creating *form;* even where the latter is not directly apparent.

Yet we see not a point, but points, and these points create forms. Between two points, line plastically appears, and with more points, more lines. This star-filled sky shows us innumerable points unequally accentuated,

for one star shines more brightly than another. And their varying brightness once more creates *forms.* Think only of the constellations. I mean only that in a starry sky, form remains unannihilated when we perceive it as natural appearance.

> **Y.** And you still find repose more fully expressed in the star-filled sky than in a flat starless sky or one with only a moon?

> **Z.** As I said, although a single point is indefinite, these many points of light lend determination to otherwise indeterminate space. In common vision they express relationship, but as *form,* as geometric figures that veil equilibrated relationship. But if we look beyond their natural massing, we right away perceive this relationship. We perceive the primordial relationship between star and star in changing dimensional relationships. We need only order these harmonically to see equilibrium purely expressed.

> **Y.** It seems to me that the special serenity of a starry sky is due to their geometric interconnectedness.

> **Z.** Everything that appears geometrically in nature shares plastically in the inwardness that is proper to the geometric. Yet the geometric can manifest itself as either straight or curved. The straight represents the greatest tensing of the curved, which has more of the "natural." Many curved lines are discernable in this starry sky—making it still "natural" and, therefore, demanding intensifica-

tion to straightness in order to annihilate its naturalness and plastically bring forth its innermost power. Whether in art or simply in conscious contemplation we must reduce the *curved to the straight.*

X. That means *transforming* the visible, the naturalistically perceptible. Yet isn't nature supposed to be perfect?

Z. Nature is perfect, but *man* doesn't need to represent perfect nature in art . . . precisely because nature is already so perfect. What he does need to represent is the inward. We have to transform natural appearance, precisely in order to see *nature* more perfectly.

Y. But isn't that a dangerous thing to do?

Z. There is a common, literal and naturalistic type of visual perception, one that is largely determined by things themselves. Thus a horse is a horse for all. This object-centered vision is truth (or apparent truth) insofar as it resides *outside* of our individual human ideas. Conversely, there is a more *subjective* vision that comes from ourselves, one that is chiefly determined by our narrow human ideas. This type of vision can indeed be dangerous—so long as it is immature; for once matured, it reverts to being objective vision, capable of transcending the subjective.

Objective vision is also the truth of the naturalistically-oriented person: it contains the immutable for him too. But the more inward person sees the immutable more

deeply: for him all things are equally beautiful—for they are basically one, one with ourselves. This more spiritualized person perceives all things as equally perfect; particular manifestations no longer exist for him.

This separates him from people who *assert* that all things are equally beautiful—yet, inconsistently, still represent their differences.

Y. I now see why the New Plastic has no place for the particular subject.

But do you too prefer this star-filled sky to a capricious landscape?

Z. As artists, we are still largely oriented to the natural, and in varying degrees still need some *appearance* in which to discern the absolute—while imperfect appearances impede this vision. In our starry sky, the capricious is already much reduced, thus facilitating our perception of the absolute.

Y. Now I also understand how you chose the subjects of your former period: they were never showed nature in its more capricious aspect. Did you always feel a compulsion to express the absolute?

Z. If the absolute signifies what is most profound in us and in all things, then that speaks for itself.

Y. I too can experience our star-filled sky as the absolute—but just as it appears!

Z. It is a beauty of life that a person is in

harmony with his own vision. It is equally valuable that truth does not permit us to *remain content* with that harmony. If you cultivated plastic vision, I am sure you too would feel compelled to tauten the curved to the straight.

Y. Then is nature simply a means for us to become conscious of the absolute?

Z. Yes. The most outward speaks to us of the most inward, the imperfect of the perfect, as all wisdom has taught.

Y. Then why do we need a plastic other than the naturalistic? Can't we learn to see that plastic as perfect, just as we can learn to see nature as perfect?

Z. But naturalistic plastic is not *nature,* any more than *art is nature.* Naturalistic plastic is always much weaker than nature. And with regard to art, *nature itself never expresses equilibrated relationship determinately.* This is the task of art.

Y. I already began to feel the need for another plastic when we were discussing the tragic character of a rising moon. As long as we perceive nature as it ordinarily appears, it seems to me, there is no escaping the tragic.

Z. There is no escaping tragic *vision* as long as we see *naturalistically.* That is why deeper vision is necessary. *Tragic emotion can be escaped only if one has learned to transform the individual to the universal by developing pure vision.*

Y. Now I understand how pure plastic expres-

sion of the universal as art can further the advancement of man, by himself, the layman could hardly succeed in coming to see nature in so purely plastic and universal a way as to trancend the individual and naturalistic.

Z. The New Plastic, while justified in itself educates us in conscious universal vision, just as naturalistic painting educated us in unconscious, naturalistic vision.

Y. Naturalistic vision . . . in truth I am never wholly satisfied by natural beauty. Nature usually leaves me melancholy despite its great harmony and beauty. I can never entirely enjoy a beautiful summer evening, for instance. I suppose it make me more clearly aware of how perfect everything could be while reminding me of my powerlessness to make it so in my own life.

Z. No one should be blamed for such self-concern. On the contrary, such a person is at least striving toward something—in this instance toward beauty! One comes more directly to the realization of beauty precisely by absorbing it *integrally* into oneself—by, as I already suggested, *losing oneself in the contemplation of beauty:* then this assimilated beauty is automatically reflected in everything else.

Y. True, but not everyone is capable of this.

Z. Of course, one must either be practiced in such contemplation, or else be an artist. The artist is capable of losing himself in beauty, at least momentarily.

Yet even for him, as for anyone who sees plastically, there are still causes for sadness, but one of a different kind, plastically expressed, and reflecting not our powerlessness in the face of to beauty, due to our own individuality, but rather the tragic that surrounds us. But generally speaking, as I have said, natural appearances in one way or another impinge on our humanity so long as we are *"men."* As "men" we are a combination of natural and non-natural opposing nature: no longer natural enough to be quite one with nature, but not yet sufficiently spiritual to be quite free of nature.

 Y. I am reminded of something a philosopher once said to me about painting: that in art we have to interiorize natural appearances so long as we ourselves are not sufficiently inward.

 Z. Was he arguing, then, in favor of nonnaturalistic painting?

 Y. On the contrary. As soon as our vision becomes sufficiently abstract, he maintained, we will be able to employ naturalistic means, so that in the future painting will return to the depiction of natural appearances.

 Z. The conclusion he draws from this hypothesis seem illogical to me. Did he think that once man became that far spiritualized he would still remain sufficiently human—which is to say a duality of nature and spirit—as to still desire or create *naturalistic* art? Besides, how close did he think we are to this evolved spirituality

risen above nature? Would it not be more modest to acknowledge ourselves as still imperfect *men,* not yet spiritual enough as to dispense with our need to spiritualize nature in art. As I see it, the philosopher was in spite of himself making a case for our new art!

> **Y.** Taking "spiritual enough" in its deepest sense, I think you are right.

> **Z.** And not taken in their deepest sense, the words are meaningless. For no one who is insufficiently spiritual can rise above the naturalistic! And anyone who evolves spiritually will inevitably abstract the natural in his plastic expression. As the esthetically creative man becomes more spiritual he will necessarily express himself in a more inward externality, for the artist transforms the outward in keeping with his own nature. Generally speaking, the more conscious man already perceives nature "otherwise" than the less conscious, or merely emotional man.

> **Y.** I too think the unconscious person suffers most from the impact of nature and that the younger we are, the more readily we succumb to nature's influence.

> **Z.** When young and unconscious, we are at the mercy of everything. To oppressive externality, we can oppose no firm inwardness or conviction. Our inwardness —what I have called our 'subjective vision'—is not in harmony with nature's objective appearance—we being too weak and nature too strong. As soon, however, as we

become more conscious "selves," we can bring our great inner force to bear on the great external one, and so escape its oppression.

 Y. That possibility allows life to become *beautiful . . .* happy are the old and strong!

 Z. Each of us is at one time young and weak and at another old and strong! It is indeed a consolation that we evolve constantly!

 Y. But nature . . . always remains equally strong and cruel!

 Z. Nature is ahead of us humans! The physical has there reached its apogy but "mankind" will reach its apogy only in the distant future!

 Y. True, man's physical aspect, his body, no longer evolves . . . unless we see evolution in the fact that spirit is increasingly reflected in the physical sphere.

 Z. In terms of cosmic evolution, we could say that man is now evolving in reverse, from the material to the spiritual.

 Y. Now surely you do not mean to separate the physical and the spiritual?

 Z. No, the physical is in general an expression of spirit, albeit a lower one. But in all of creation, man is unique: he attains *self-awareness* through physical existence, and thus *exists* as a conscious being. But besides or rather beyond his ordinary life, there is another, an

abstract life that must be taken into account if we are to gain a clear conception of art. In order to understand the evolution of art from the natural to the abstract, we must also understand that *human* evolution is continued in the physical as an *interiorization.* This evolution can be regarded as spiritual, and at the same time—seen outwardly and in reverse—as physical. In life, these opposing evolutions are generally unequal and in conflict. Yet equivalence between the two is necessary in the interest of equilibrium. Advanced spiritual evolution cannot be pure in a person whose naturality has not matured in proportion. This is why so many of us lapse into a surface spirituality. *And so it is that in contemporary art no pure expression of the genuinely spiritual, of true inwardness is possible using form of the most outward kind.*

 Y. I see more clearly why the new painting can no longer express itself by means of natural appearances, and am therefore resigned—theoretically at least—to the destruction of naturalistic representation.

 Z. In the New Plastic, however, destruction at the same time implies *reconstruction: equivalance of the physical and the spiritual in one.* The natural is not destroyed, only stripped of its most external character. Then apparent unity becomes *duality,* and apparent duality becomes *pure unity.*

 Y. Yes, I have read about that in *De Stijl.* According to superficial opinion the New

Plastic attacks or denies nature.

Z. Only from a superficial point of view. We can hardly expect everyone to understand the unfamiliar other than superficially.

Now a moment ago we were discussing man in relation to nature. Nature supplies something, and so do we. We act upon nature, one might say, and nature makes a powerful response. In brief, nature manifests itself plastically, while we tend merely to fantasize. Only in the moment of esthetic contemplation do we cease to fantasize. It is then that we open ourselves to the manifestation of truth, and behold beauty pure!

Y. Nature, you said, expresses the tragic. Can the tragic be beautiful?

Z. The tragic can be beautiful—everything can, the apparently good just as the apparently evil. The revelation of the truth may seem cruel to us, but the pleasing is not always the beautiful. Earlier I said there were *degrees of beauty.* Equilibrated relationships form a deeper beauty than does tragic expression. Nature manifests truth as beauty but in natural appearance it can only express it *veiled* in form, and this veiling of truth results in the tragic.

Y. So nature expresses the tragic at the same time as we have the tragic *in us?*

Z. Subjectively, the tragic results from the domination of the natural within *us;* objectively, from the domination of the natural *outside of us.*

Y. And we can neutralize the tragic only through the evolution *of our entire being,* inward and outward, nature and spirit?

Z. Neutralize . . . all we can achieve for now is an improved outer equilibrium of opposites. Complete abolution of our inner tragic is achievable only in the distant future—and likewise the tragic outside us. If we consider the external as *part of ourselves,* or, as I said earlier, if we regard *ourselves as part of nature,* even then it will lie in the very distant future; for only then will the interiorization of our entire being become a reality. At present it occurs primarily in our minds. Eventually, natural appearance will cease to exist: *duality will become one in reality.*

Y. If duality brings the tragic, then how can the tragic be part of nature, which appears as unity?

Z. Nature's unity is only apparent. Nature exhibits the purely external more often than it does the pure plastic expression of interiority: otherwise stated, the purest exteriorization of inwardness is veiled by the capricious, which, as I indicated, is the visible expression of the tragic. For while inner and outer may appear as one, they are not. Pure unity is manifested as equilibrated *duality.* So to express true unity, we must express it as apparent *duality.*

Y. Now that I understand your apparent dualism, I agree that painting must adopt as plastic means an equilibrated duality,

which will replace natural form and naturalistic color.

Z. *Equilibrated duality:* this is what, in life as well as in all reality, can ensure greater joy through greater harmony. But how, at present, are we to find equilibrated duality? The duality of man and nature is *by no means* equilibrated. Equally disequilibrated is the duality of appearance and force, of outer and inner in nature. And in life the dualities of material and spiritual, of the male and the female, are generally disequilibrated. The *solution is to be found only in ourselves.* For equilibrium between the opposites to become possible, our consciousness should have matured to the point where *the natural, the material, has lost its oppressive power, and the spiritual has come to clarity. Only in this purified duality is unity possible.* The external, however, does not suddenly change of its own accord; but it does change *for us when we experience it in its inmost essence abstractly.*

Y. In this way the plastic expression of art must also change?

Z. Only in this way. Given this *experience of the abstract* art too is transformed from naturalistic, to *abstract.*

Y. Even though the beauty of this New Plastic still eludes me, I have to say that the conception strikes me as very *logical and real.*

X. Regardless of all this, certain aspects of

nature just as *it appears to me* still seem to exhibit the greatest possible harmony, and I find it hard to imagine it expressed in any more perfect way than that of nature.

Z. As I said: harmony is not the same for everyone. It is a matter of conception. To be sure, natural harmony is present in nature, but the equilibrated relationships of the abstract represent another conception of harmony. That the concept of harmony is relative *perfects itself* with time, is demonstrated not only by the succession of art forms, but to some degree by the life of every artist. For it is precisely the beauty of the artist's effort *that he continually strives toward a purer expression of harmony.* With each new vision of beauty, he discovers more clearly that *the harmony to be found in existing things is so powerful that visual representation is incapable of rendering it.* As you yourself know, the artist constantly transforms the objects of vision toward greater plastic harmony. After ecstacy comes dissatisfaction—and a new plastic expression. *Reflection* and *comparison* rob him of his satisfaction with the achieved harmony. And even though the Neo-Plastic conception of harmony is in the end the most satisfactory, it too falls far short of our most inward and, alas, still insufficiently conscious *idea* of harmony. The power of the harmony inherent in existing things must be attributed to the *living beauty* of nature that acts upon *all our senses* simultaneously For nature does not move us through visual appearance alone.

Y. It seems true to me that the *expression of harmony,* not natural appearance, is the main thing.

Z. That is why art arrived at the New Plastic. *Achieving harmony* is the main thing in life too.

X. But assuming that it is possible to interiorize the external in art, this is harder to achieve in life itself. I fear you are not taking reality into account.

Z. Our evolution is ahead of current reality— but life does catch up! Material domination must be, and is being, reduced. The conception of deeper *harmony through equilibrated duality* is truly at work in contemporary life. One example is modern social dancing in couples. Formerly the music and the dance movement flowed together in a way that could be expressed as a continuous curved line. Today, however, the advanced dance forms and the music to which—or rather against which—one dances manifest themselves as an *equivalent duality* that could be expressed as a straight line. The musical rhythms are opposed not only to one another but also to the melody, just as the dance steps oppose one another. A *far higher degree of unity ensues.*

Y. But such changes are almost impossible, it would . . .

Z. It would cost enormous exertion and training on both sides—*that is ever the price of equilibrium.*

X. I always thought that equality created monotony; but in dancing, I think this is not so. But in dancing there is already a *distinct duality.*

Z. Quite right, *distinct duality* is necessary in art as in life. Equivalence *does not* imply equality or sameness, any more than it implies *quantitative equality.* The latter could easily produce stasis in life and monotony in art. That is why in the New Plastic we have equilibrium opposites, therefore determined *duality. Rhythm* is one opposite and the *variable relationship* another. Variable relationships of *dimension* form one opposite and the invariant relationship of *positional* is another. In the plastic means, *color* is one and *manifestation of the plane and perpendicular* the other. With regard to position, *horizontal* is one and *vertical* the other, and so on. Precisely because the duality is so *distinct* it takes a great deal of effort on the part of the abstract-real painter to find equilibrium between these opposites. If he expresses *one,* it is the expense of *the other—*and if he expresses *the other* as purely as possible, its counterpart will suffer. But by working he eventually finds a more or less satisfactory solution.

X. But dancing remains very close to the natural, despite a certain intensification.

Z. That is quite relative. If you compare the straightened lines of modern dress to more natural clothing or to the unclothed body, you will have to agree with me. Besides, the dancing I mentioned is not art of the

highest type: *pure* art requires more.

> **X.** I still cannot accept the idea that we must seek plastic expression outside nature and outside reality.

> **Z.** Neither do I and nor do we have to. On the contrary, we must seek the plastic *in* nature, *in* reality. And that is just what painting has done: *it came to abstract reality through naturalistic realism*—along the path of *pure plastic vision.*

> **Y.** You said earlier that plastic vision means union with the universal. What does that involve practically? Does it mean that seeing into things as they truly appear plastically?

> **Z.** Plastic vision means *conscious* contemplation of things; or more precisely, contemplation *through* things. It means *distinguishing, perceiving truth.* Plastic vision causes us to compare, and thus see *relationship*—or to see *relationships and therefore compare.* It means seeing things, so far as possible, *objectively.* Plastic vision also means being plastically *active.* In seeing plastically we automatically destroy *the natural and reconstruct the abstract appearance of things.* Seeing plastically, we in a sense perfect our ordinary vision, thus *converting the individual back to the universal.* Thus pure plastic vision unites us with the universal. *Esthetically,* pure plastic vision expresses truth through beauty, in which it remains to some degree veiled. But this beauty can no longer be the

most external beauty, if only because pure plastic vision sees *through* things. In comparison with ordinary vision it has become an *abstract* beauty.

> **X.** But even supposing nature could appear to us so abstractly—wouldn't we find everything dead and meaningless?
>
> **Z.** The fault would then lie not with the

abstract appearance, but with our attachment to the natural. True, I said "art is not nature." I will now add "nature is not art," nor need it be. Nature becomes art only through *man.* It is for the human spirit to *express* plastically what nature evokes in our human *nature.* In fact, is not the basically geometric character of our urban environment already very abstract by comparison with rural nature?

An abstract representation can affect us deeply. For example at the outbreak of the Great War I saw a film depicting much of the world in the form of a map, upon which the invading German forces appeared as little cubic blocks, and the opposing Allied armies as other little blocks. In this way the global cataclysm was *plastically represented* in its immensity, not in diverse details or fragments as a naturalistic representation would have done.

> **X.** Granted that such a method is useful for

depicting global events; but a naturalistic representation usually affects us more deeply.

> **Z.** Pure plastic vision looks upon *everything*

as a global event, although I agree that a naturalistic repre-

sentation impinges more strongly on our *natural* feeling.

X. Speaking of films, I remember one depicting the struggle between a crab and an octopus. Here again were two forces striving to annihilate each other, but here the depiction was more realistic.

Z. There is no argument here. How, and how deeply we are moved will depend on ourselves. I wanted only to point out that an abstract representation can indeed be moving. My example did not properly bear on abstract *plastic,* since we already knew something of the events. The plastic expression suggesting collision and conquest was not independent of the already familiar ideas of conflict and collision. We nevertheless see how effective expression by abstract means can be.

Y. That abstract representation conveys a more general impression, I fully agree. The particular falls away and the universal comes to the fore. Representation of the natural in *projected* form, like the world in your film, does communicate a more general impression.

Z. Projected representation is superior to naturalistic expression in that it helps us to see *relationships more purely.* Indeed Cubism understood that perspective representation confuses and weakens the appearance of things, while projection represents them more purely. Precisely because it sought to depict things as completely as possible, Cubism came to represent them in projections. By presenting several projections simultaneously,

side by side or superimposed, the Cubists achieved not only a purer representation of things but also a purer plastic—or as the Cubists say, expression of their volume.

X. Yet we always see things from single standpoints!

Z. In the individualistic, subjective conception, yes. But as soon as we see ourselves as part of *a whole,* as soon as we cease to rely exclusively on our temporary position and view things from all possible positions, in short, as soon as we begin *to see universally, then we no longer view things from a unique viewpoint.* It is an encouraging sign that the new painting strives ever more consciously for a pure and many-sided representation of things, for this betokens a new and more conscious spirit that desires the universal with greater determination. This modern aspiration has been attributed to growing knowledge of the *fourth dimension.* The concept of a fourth dimension in fact does appear in the new art as *partial or complete destruction of three-dimensional naturalistic representation and its reconstitution in a new mode of representation in accord with less limiting vision.*

Y. And this broader perception came about through the cultivation of vision?

Z. Yes, cultivation of vision produced *pure plastic vision* that made Neo-Plasticism possible.

Y. Now, is plastic vision possible for the

esthetic person alone?

Z. Plastic vision is the way for modern man even outside the esthetic sphere, for it is no more than *conscious perception of truth,* thought exercised plastically. We can also try to practice plastic vision in our lives. It will show us how to perceive reality more reliably than through intuition. For our intuition is still clouded. Pure plastic vision will in general reduce our particularity and lead us toward the universal—then everything will automatically *be done* from a more universal standpoint.

Y. That should strongly benefit social life.

Z. *Pure plastic vision will create a new society, just as it created a new plastic in art—a society of material equivalence, a society of equilibrated relationships.*

Scene 4. A mill from close up, dark and sharply silhouetted against the bright night sky—its arms arrested in the form of a cross.

X. What grandeur here too! You, Z, must especially appreciate it. Just look at those sails.

Z. I indeed appreciate the mill's beauty, especially from as close as we now are, so that *normal perspective* is denied and we can neither view—or draw—it in the *ordinary* way. Under these conditions it is hard to simply reproduce what we see: we are obliged to attempt a

freer rendering. Several times in the past I tried to depict something from close up, precisely because of the grandeur this confers. Then, as now, I was struck by the cross-form presented by its arms. Now, however, I discern the perpendicular in *everything,* so that its arms appear to me as no more beautiful than anything else. From the *plastic* viewpoint they even have a drawback: with the upright cross, especially, we tend to associate particular, rather literary ideas! That is why the New Plastic continually annihilates any cross-form that may arise.

 X. How pure is the blue of the sky against the darkness of the mill!

 Z. Yes, the sky is pure—but so is the mill! *Visually* the mill simply appears as dark and colorless. But I have found light and dark paint alone insufficient to fully render the effect of mill and sky. For drawing, light and dark fully suffice; but color expression is more demanding. The blue requires opposition by another *color.* The Impressionists already exaggerated color; the Neo-Impressionists and Luminists went further. In my own experience, I found it satisfying to paint the mill red against the blue.

 X. Surely that is not how we see it?

 Z. *Inwardly* we see otherwise than we do visually. But inward vision is not always *conscious.* And when it is not, then—despite the greater freedom and spontaneity that inner vision offers—we tend in our plastic

to cling to ordinary vision especially after our first rush of emotion has subsided. It is especially the power of that first, intuitive emotion that makes the sketches and studies of naturalistic painters so often stronger and more beautiful than their paintings. The difference between esthetic vision and normal vision must always be borne in mind. What generally matters in art is to reflect our esthetic *emotion.* The more intensely we feel the purity of color, the more we will want to express it in a plastically pure fashion. Even in particular representation, as our vision becomes more esthetically *conscious* our task becomes that of expressing our esthetic emotion determinately. Then we break completely with ordinary vision.

> **X.** But surely many fine things are produced without exaggeration.

> **Z.** What for one person is exaggeration can be feeble reproduction for another. This might make art appear to be highly subjective, were it not that we observe over the ages *a consistent striving toward a stronger and purer rendering of the perceptible.* Time beats ever faster, its rapid tempo creates a more vital emotion, which in turn demands a more powerful expression—so it seems from the standpoint of emotion. But it can also be said that the consciousness of our age moves increasingly from the vague to the determined. Or again that the contemporary spirit demands greater clarity.

> **X.** Could not the exaggeration, so prevalent

today, be explained simply as one artist imitating another?

Z. How is it, then, that the same is seen to arise in so many places independently? Besides, people—and especially artists—don't usually take to anything new unless they are convinced of its truth. As yet such insight is not common, but when the new is adopted, it may be more or less superficially, simply because one is ready for it. Here again it is not just a matter of "imitation."

X. But to return to the mill. . . . If the exaggerated color satisfied you, why didn't you continue working that way? Why did you discard all form?

Z. Because otherwise objects as such would have continued to be present in the plastic expression, too. So long as they are, the latter cannot be purely plastic. When "things" are in evidence, this always limits the esthetic emotion. Therefore the object had to be excluded.

Scene 5. A garden with artificially shaped trees and shrubs—a house.

X. Here we see a real tensing of line. . . . but I prefer nature as it is!

Y. I rather like what has been done to the trees. They go well with the clean lines of the house.

Z. Yes, they create an effect of unity. Man

wanted to establish a link with nature, so he "transformed" nature. And in this transformation we see man's drive to intensification.

X. But this is not yet taughtening to *straightness*—notice those rounded forms.

Z. The tautening could be called only half-complete and there is no question here of tautening to the absolute. What we see here is little more than a *generalizing of form:* an improvement *of form*—not its *abolition.* So here, just as in capricious nature, we see relationship within form, not relationship *by itself,* consequently no *pure* relationship.

Y. From what you have said, I gather you have another solution in mind. First you would abolish *form;* then you would seek to establish equilibrated relationships. But then wouldn't everything be quite *flat?*

Z. This garden brings us from painting to *sculpture,* which deals with the third dimension otherwise than does painting: the painter has his three primaries plus black and white; the sculptor only black and white. The sculptor has to find the straight in three dimensions. Thus he produces a corporeal plastic. He can, however, reduce the roundness that is a characteristic of *form* to the prismatic, and in turn annihilate the particularity of form by breaking and opposition. The way of the Neo-Plastic sculptor will probably be found in prismatic compositions.

X. Then would not sculpture be transformed

into architecture?

Z. Far from it. Architecture remains space construction, and must satisfy practical requirements. Sculpture is more free.

X. In your view, then, this garden is more akin to pure sculpture than it is to a "picture"?

Z. Certainly: sculpture, as I see it, will have to completely discard the pictorial.

Scene 6. The façade of a church—seen against the darkness as a broad plane reflecting the light of the city.

Z. Here is yet another *reality:* but still not *abstract* reality.

Y. Yet isn't everything in it *flat and geometric?*

Z. The abstract is *inwardness* brought to determination, or externality spiritualized to the highest degree. It consequently has nothing of the indeterminateness seen in elements of this façade: The abstract can contain none of the *forms* repeatedly found here.

Y. But wasn't the church built in a specific style? Might its builders have failed to determine the right proportions?

Z. They did not start from a search for pure equivalence, but rather from a certain concern with balance and harmony. In architecture, the exterior reflects the

inner *construction.* If the inside is not purely equilibrated, neither will be the exterior. For this reason, *architectural construction* will have to be altogether transformed before it can form part of the New Plastic.

Y. So all the architecture of the past only *inspires* you to abstract-real expression . . .

Z. So long as there is no *completely new* architecture, painting will have step in and supply what architecture generally lacks: the establishment of purely equilibrated relationship, or abstract-real plastic.

Y. But isn't architecture palpably *real?*

Z. The palpably real can also be abstract-real, just as a picture is in one sense palpably real. The New Plastic expresses in painting today what will someday surround us as architecture and sculpture.

Y. So you believe the New Plastic will prevail *universally* in these arts?

Z. Universally . . . that will take a long time. The pioneering is always done first by *individuals,* then by *groups.* There are already a few buildings that demonstrate the aims of the New Plastic, but for an entire city . . . much time is needed! For a long time our surroundings will fall short of abstract reality. That is why abstract-real painting must remain our model for now.

Y. So you must find our towns and villages rather irritating?

Z. To some extent. Especially in small towns

and villages, individualistic feeling—the time-bound is very strong. It is of course also present in individual buildings of our bigger cities, but there everything dissolves more readily into the mass. The time-bound is less prominent in the *metropolis, where the beauty of pure utility* is more apparent.

Y. But can the purely utilitarian be *beautiful?*

Z. The beauty of pure function is demonstrated by many objects of every day use. A simple drinking glass is beautiful, so is an automobile and an airplane. And, to cite only things of our own time, so are works of modern engineering bridges, factories, and so on, in metal or concrete. Perhaps the architect's greatest mistake is his attempt to *impose beauty.*

Although the conscious plastic quest for beauty is the highest, a conscious search for beauty has many pitfalls. As long as one is not conscious plastic expression, it is preferable to confine oneself to the useful. By doing this purely, one focuses on life. Conversely, attention to life is attention to utility. And isn't art precisely attention to life? Precisely by not paying attention to life, art was distracted from its course by the desire for agreeability and prettiness, for the luxurious and the decorative, and so on.

Besides, to return to your question, equilibrium is a law of nature: essentially it is *truth,* and all manifestations of equilibrium *in material* life are therefore *beautiful.* Were man purely to seek equilibrium, then automatically his products would become beautiful.

X. But this would put the ordinary man on a level with the artist. What about the latter's artistic emotion?

Z. An artist need be no more than a pure man who expresses himself through esthetic plastic in, if you will, a creative way . . . but neither should he be less. Now this is no small matter: everything is involved. Such a man will indeed be *moved* by equilibrium rather than by accidentals. So he is not without emotion! His own "equilibrium" allows him automatically to bring growing equilibrium to his creations. In this way he seeks and creates beauty without aiming at beauty. Otherwise, an ordinary pure person without esthetic emotion is preferable; for even *without emotion* he will create a certain beauty through pure feeling and intellect. The engineer, for example, limits himself to pure construction: pure relationships come about spontaneously, through *the necessity that is truth.* Think only of the Paris Metro: the beauty of its construction, perhaps too cold in itself to satisfy artistic sensibility, becomes alive through light . . . itself placed there out of pure necessity. The new works of engineering have the further advantage of purely expressing the necessity of the age. The old form and style are increasingly abandoned . . . once more from necessity, since new materials call for new structures.

Y. How admirable that beauty can grow of its own accord!

Z. Yes . . . in spite of all. Already we see pure beauty in buildings created for use and from need: housing groups, factories, big stores, etc. But as soon as "luxury" comes into the picture and one begins thinking in terms of "art," then pure beauty is compromised.

X. But does everything have to be simple and poor?

Z. Pure beauty is never poor, and strict simplicity is preferable to capricious luxury as long as true richness and esthetic quality are not possible. Let the rich use costly materials in their homes, but not treat them decoratively. Let the artists concentrate exclusively on equilibrated relationships of form and color, and their work will never be poor, although its character will vary with the materials. But for all this to be widely realized, social life, too, will have to be purified. From this purer life a new beauty will spontaneously arise.

Y. To a new beauty corresponds a new man.

Z. The new man will indeed be completely "different" from the old. The new man performs all the material activities, but out of necessity and from a different motivation. He experiences material life without enjoying it or suffering from it in the old way: he uses his physical being as a perfect machine . . . without *himself* becoming a machine. The difference lies *precisely* in this: formerly man was himself a machine; now he *uses* the machine, whether his own body or a machine of his own making. To

the machine he so far as possible leaves the heavy work while *he* concentrates on inwardness. On the highest level, his soul too becomes a "machine": and he *himself conscious spirit.* In art the difference can be described in this way: the old art is an unconscious expression of harmony through material consciousness. The new is plastic expression of purely equilibrated relationship through spiritual consciousness.

 Y. I don't see too many of these new men!

 Z. I posit the new man only as a "type" so far appearing in an approximate way . . . but he *is* appearing! And logically, he will be alien to the man of the past, alien to his art expression as to everything else. So, too, he would be alien, for example, to this church.

 Y. The church affects me, nevertheless, with a powerful impression of grandeur and solemnity and repose . . . rather like this evening's star-filled sky.

 Z. Unquestionably; here we fully agree. Such things as grandeur, solemnity, and repose are *fundamental* and basically independent of particular appearances. But *through what agency* did you receive that impression? Were these basic feelings communicated through the *forms,* now receding into darkness? Or through what *lies veiled in the forms,* and now emerges as it grows darker. And as you experience esthetic emotion more consciously or, which is the same, in more purely plastic fashion, you will agree that these fundamentals aspects are strongly

affected and *colored* by form.

Y. And if it is not the forms, then it is once more we who veil these things. I recall, earlier this evening, your stressing apropos the stars into which we read forms, that it is we ourselves who transform the visible.

Z. True but with the significant difference that in the case of the starry sky we were less constrained by form and could easily lapse into *creating* forms on our own. In the case of this church, on the other hand, our vision is more determined by its forms so that it is harder for us to create them ourselves. The difference amounts to this: in the case of the church we are constrained by something other than us, but in the case of the starry sky, by our own selves.

Y. For my, part, I found purer beauty in the starry sky! My impression was "other" than the one I received from the church, but it is hard for me to differentiate their effects. Sometimes I favor the one, sometimes the other.

Z. Experience is a complex matter. We have to reckon not only with ourselves but also with what we perceive. I purposely say "perceive" rather than "see," for *all* our senses are involuntarily at work.

Truth appears in all things differently, and in all people differently. So it is good that there are such diverse things and such diverse people . . . in that way we arrive at the *complete* truth.

Y. So unity is beyond human reach? There are nevertheless "styles."

Z. Individuals temporarily achieve "unity" in groups, which can give rise to a "style." And they seek progress in groups . . . one group overtakes another: thus old and new can exist side by side.

Y. When it comes to buildings, how the old lives on!

Z. . . . if nothing befalls the building, of course.

Y. This edifice takes me back to times long past! How beautiful it is!

Z. Indeed. As soon as we have so to speak gotten past our first esthetic emotion, we become confined by our *thoughts of the past*. We see certain "stylistic" forms that are not *our own*. Stylistic forms are always more or less *descriptive*.

X. Still, the descriptive can also be beautiful.

Z. So it can, but it weakens pure plastic beauty. *The descriptive is time-bound and constantly changing, changing. All appearances change, everything moves, everything is in flux, as the ancients already knew. Everything changes, including ourselves . . . we are always becoming other than we were.*

Y. Is this not a tragic fact? Where is anything stable to be found?

Z. Outwardly it is tragic, but inwardly it is

happiness. *For motion is not in vain.* Deep in the changing lies *the immutable—which is for all time.* The immutable is manifested as *pure plastic beauty.* And that beauty—in the case of this church by a variety of obscured forms—is for us a *living reality.* It is *universal beauty.* The New Plastic seeks to bring it out clearly. The succession of styles served gradually to disclose it. Finally equilibrium found *pure* plastic expression through *pure* means: *through the straight line in dimensional and positional relationship.*

Y. Architecture seems ideal to this end!

Z. I think so too. Although there are great practical difficulties, they can be overcome.

Y. If the spirit of our age everywhere demands clarity, then why does art usually lag behind?

Z. Yes, why should universal beauty remain hidden in art, while the sciences strive for all possible clarity? Why should art still follow nature while everything else seeks to leave nature behind? Why doesn't art present itself as a counterpoise to nature? And which one of the arts is best suited to keep this counterpart before our eyes? *It is architecture's great task to keep universal beauty clearly before our eyes, and in that sense, collaborate in unity with painting and sculpture.* Once mankind accepts this idea it will be realized, and the old will automatically disappear: But how those old stones endure! A

new idea manifests itself as a new appearance. How the old will vanish, we do not know. All that matters is to establish a clear image of the new! The great mistake is to continue *thinking in the old ways!* For this, the old environment is partly to blame, although on the other hand the sight of the old can incite the new spirit in an opposite direction . . . the *new,* the *strong spirit:* the weak who usually have the necessary funds, will *follow.* So it is perfectly natural for modern man to resist the old or, rather, whatever confines us, as the Futurists made clear. It is difficult, however, to offer a better substitute, and so long as we cannot do so, it will help little to simply abolish the old—as we see in practice when cities and villages destroyed by the war are rebuilt in the old manner! So long, then, as the old persists, it remains *necessary.* Time will take care of everything, but let us do all in our power to hasten that time. It can be done!

Y. But how and by whom?

Z. As I said: *by establishing in ourselves a clear image of the new.* We are all capable of this, but only architecture can make it real. We can all contribute. Architecture has only to realize tangibly what Neo-Plastic painting demonstrates abstractly. It is the architect and the engineer who will create the future harmony between ourselves and our surroundings. For now, we continue to live in the old!

Y. And while living in the old, it is hard—even

for the strong—to avoid falling into the same rut.

Z. True. What surrounds us now? We live as strangers in the house of another, with another's furniture, rugs, utensils, and paintings! The streets, too, belong to another. The theater is equally alien to us. And the cinema? Between its old-fashioned morality and its so-called naturalism, even the cinema is not of our time.

X. Yet is there no beauty in all this?

Z. There is, but a puerile beauty. *The old art is destined for children; the New Plastic for adults.* And just as the adult is a stranger to the child, so is the new man—for whom the New Plastic is destined—a stranger to the old art. Adults live on a different plane . . . but we will return to that.

Y. But many adults fail to understand the New Plastic.

Z. That is due to unfamiliarity or to undeveloped vision. We reach adulthood along different ways, according to our nature. I am speaking of art as art.

But to return to the beauty of the old: if it were not in fact so beautiful, people would continue as they do to surround themselves with it, even on their way to adulthood! Of course they are beautiful, those old-style houses, that old-style furniture, beautiful indeed, but theirs is a beauty that no longer *moves* us and so—for us—is no longer beauty. While I appreciate the genuinely beautiful things preserved

in museums, I no less strongly dislike being forever surrounded by objects bearing the same stamp of antiquity but of far lower artistic merit!

> **Y.** But isn't mere weakness to be influenced by all that?

> **Z.** *It is precisely for the weak that I speak. The strong are able to go their own way and establish a new beauty . . .* even if one not yet tangibly realized. In any case, where shall the new man find his home or city? Unrecognized by society, he lives as an outcast within it.

> **X.** Would you, then, want new buildings for each generation?

> **Z.** That's what a certain Futurist architect claimed. But it would surely be preferable to design *buildings* for at least several *generations.*

> **X.** But what if each generation is indeed "other," as you say?

> **Z.** Then it still is—or will become—possible, so long as *the buildings represent a pure manifestation of the immutable, of that which remains constant throughout the generations.*

Scene 7. Z's studio.

> **Y.** We have seen so much beauty tonight. A pity it is over.

> **Z.** The evening is over, but its *beauty*

remains. For we have not just "seen" visually; an *interaction* has taken place between us and the visible. Such an interaction must have produced something. It engendered more or less determinate plastic images—which not only remain with us but will gain in strength now that we are alone with them away from nature. *Now these images, rather than what we saw, are for us the true manifestations of beauty. Practice the clear vision and retention of images of beauty: in the end one lasting image of beauty will remain with you.*

> **Y.** That seems ideal but something not easy for a layman to achieve.

> **Z.** Admittedly, whether by disposition or by training, artists are constantly preoccupied with the formation and preservation—of images of beauty. The naturalistic painter seeks to form a fixed image of the natural. Because *he* always forms it according to *his* particular emotion, his image too will differ from ordinary perception. Likewise the Cubist seeks to extract a permanent image of things. Because *he sees things* in an altogether different way, his image will differ even more from ordinary perspective appearances. And the abstract-real painter forms his own fixed image of the visible. He allows it to react upon him, and in the process of working arrives at an *abstract image of relationships.* Thus we see the image of beauty developing in the artist and in a sense freeing itself from objects. *In freeing itself from things, it grows from individ-*

ual beauty to universal beauty. The abstract image of relationships is the one most free of limitation or attachment, thus free of the tragic inherent in the material and individual the purest expression of the universal. *The universal is generally unattainable within traditional attachment to the individual.* In art, the universal *cannot be determinatedly expressed by means of natural form*—a fact to be pondered by today's disciples of "universalism."

> **Y.** In life this certainly holds. In art, I am not so sure.

Z. As it is in life, so it is in art, and conversely. As we free ourselves from attachment to the individual, our image of beauty also becomes freer, and conversely. Freeing *our image of beauty reveals and at once advances the evolution of our life.* If such evolution entails the destruction of individualism, each time the latter matures *in us,* then we will automatically destroy each image of beauty—as soon as it, too, *has matured.*

> **Y.** A pity that evolution is so unequal, that those whose image of beauty is already mature stand isolated among the masses.

> **Z.** Indeed, for so long as their image of beauty has not matured, it cannot be annihilated.

> **Y.** So we cannot hate those who think differently from ourselves.

Z. True. There is nevertheless a certain clinging to tradition that can only be called criminal.

Whether from sloth or weakness or whatever else, one does not wish or dare to destroy the image of beauty that has fully ripened *within the spirit of the age.* And that is tantamount to denying a new life. Man is destroyer as well as creator and conservator . . . that is how all wisdom has described his noble destiny.

 Y. But by this destruction, one also destroys oneself in relation to society.

 Z. True. As society is now constituted, whomever breaks with the old forms damages himself materially. In fact by breaking with anything one tends to damage oneself, at least temporarily. But this is of no concern to the new, which cares little for time.

 Y. I think this is why many artists, involuntarily and without even realizing it, remain mired in the old.

 X. But isn't it preferable that they continue to create the old beauty rather than give up the creation of beauty altogether?

 Z. As I see it, the latter is preferable. But as you know, I tend to the radical. It is true, however: with each new art form the outlook worsens. As each expression leaves the natural further behind, it becomes more incomprehensible to the materialists—who hold the purse-strings in our society. The new must be present a long time before it gains material value. Think only of Van Gogh; even today he is accepted by relatively few.

Y. Yes, it is a sad fact that the new must at first be sustained by evil. I am thinking of *speculation* in works of art.

Z. Proving that sometimes when seen in the broad line of evolution, evil is no longer evil. Generally speaking, everything, good or evil—perhaps especially evil—furthers the growth of the new.

Y. It is a remarkable fact that evil sometimes thrives on the good. Art dealers who have obstructed the new nevertheless profit from it—once it has become fully established as the "old."

Z. But when you consider that, even if unintentionally, they give the esthetic material value, then we again see the bad as the good!

Y. As another instance of the bad living off the good, consider the critics who live in part by maligning the new.

Z. But the good benefits from this also. Even deprecation stimulates the new!

But returning to the destruction of form: we must continuously discriminate between *images of beauty, until our image of beauty has become purified and deepened.* Art shows a series of expressions that grew from the naturalistic to the abstract. This could occur only through continual destruction and creation. I have already spoken of the Naturalistic, the Cubist, and the Abstract-real images of beauty in relation to nature. Finally, the

artist *no longer needs a particular starting point in nature in order to form an image of beauty.* When he becomes more conscious of the universal, the particular having lost its dominating power, his greater consciousness will automatically cause him to express equilibrated relationship. He *has then internalized the outward: it is still in him*—and will move him.

> **Y.** True: emotion is an interaction of outward and inward.
>
> **Z.** Yes: of universal and individual. But here

the individual has matured: with regard to art, we could say that *the particularities of nature have been transformed to unity in memory.*

> **Y.** Yes, art in general is an image of memory.
>
> **Z.** Or the search for harmony between esthetically inward, or intuitive, and outward, memory.
>
> **Y.** But are memories real?
>
> **Z.** What was real a moment ago is so still,

and you continue to exist now, no less than before. Has the connection between you and things ceased to exist just because you no longer see them, or are looking at something else? Besides, isn't the one just as real as the other, and so cannot the one make completely real the memory, the retained image, of the other? Is not our capacity to perceive beauty constantly there?

> **Y.** Indeed it is: and that capacity must be

strong indeed—particularly in the artist!

Z. But the layman too can possess it to a degree, sometimes even to a high degree. So why shouldn't he, too, be capable of cultivating an image of beauty? The same path lies open to him. All he lacks is training in the artistic means, but he has the same opportunity to practice plastic *abstraction.*

Y. You have proved that to me this evening. But it is difficult . . . the layman is always busy in so many other directions. How happy you must be to live so constantly with beauty!

Z. Relatively happy. An artist can be completely happy *only when his image of beauty accords with the world around him.* A naturalistic painter can of course be happy with nature or natural reality in general. But the abstract-realist painter knows another beauty: the beauty *he expresses plastically,* but that he finds always obscured in natural reality. For happiness requires harmony: harmony between outer and inner. The new man seeks spiritualized outwardness: only with it can he be completely happy.

Y. Therefore the more natural person is happier?

Z. No, he finds complete human happiness only in relation to, in, or through the natural. Fortunately, the new man is no longer happy in this way . . . for that is a *limited* happiness. The happiness of new man is freer, stronger, more constant. It is only more *inward.* But its

complementary outwardness is still lacking, and it is there-fore incomplete.

Y. Such, then, is the happiness of the abstract-real-life you were describing?

Z. Yes, this inner life will create its outward-ness: abstract-real life will become realized in outward life, thus in all externality: then the new man will find *his* own externality. Then he will be completely happy.

Y. Spiritualized outwardness is certainly hard to find today.

Z. And if one does find it, in another person, for example, external obstacles stand in the way. Everything at present is dominated by *the most* external and material factors. Consequently, the artist of today can be happier than the non-artist only to the extent that he may be temperamentally suited to abstract-real life. It is indeed hard to concentrate on beauty in this society: amid disequilibrium it is hard to concentrate on equilibrium. But we'll return to that. It still depends chiefly on ourselves how far we let ourselves be absorbed by everyday con-cerns, and how far we manage to cultivate an image of beauty. To concentrate on this is no luxury! *An image of beauty that is freer of materialism will re-create our materi-alistic society.*

In society, not only the layman, but the artist, too must think of more than just his work. You said it was difficult for the layman to focus on beauty. But the artist,

too, is excessively preoccupied with material problems. And, as you pointed out, for an artist who has broken with the old, it is especially hard.

> **Y.** I am by no means surprised that this studio is *yours.* It breathes your ideas; it is altogether different from most.

> **Z.** Most painters are altogether different.

The two things go together. Most painters cultivate the old: they like to surround themselves with antique furniture, sculptures, carpets, and so on.

> **X.** Understandably: painters desire beauty and such things are beautiful!

> **Z.** Of course they are beautiful, but ancient—

we discussed that. I think the growth of a new principle of beauty is thwarted when the artist chooses to turn his home or studio into a sort of museum of the old art—usually of mediocre quality at that. In this way he creates an atmosphere where the new is out of place and the old lingers on. And the layman follows the example of artist. The artist of today must lead his age in all areas. My studio conveys something of the Neo-Plastic idea. Here equilibrated relationships to some extent find determinate expression through line and color alone. The studio's structure was not unfavorable, since it already showed a degree of spatial articulation in which relationship is expressed. Which is more than can be said of many other rooms. Our Dutch rooms especially tend to be poorly laid out architec-

turally, and are in the main no more than a space bounded by six empty planes, with openings for doors and windows. The space is then articulated by whatever the owner chooses to place or hang in it. French rooms generally have more articulation of their own. More attention is paid to the paneling, to built-in fireplaces and mirrors, to the flooring—features in our country usually limited to the homes of the well-to-do. And even then our wall surfaces remain *unarticulated* or divided in unequilibrated ways.

Y. True, rooms can be very different.

Z. The difference stems from articulation and *color.* The same thing is noticeable in many French shopping streets. The various shop fronts are distinguished by means of color or light and dark. They form a *composition of color planes* expressing relationships in a determinate way. But I have found architectural and decorative articulation in our country too—notably in Brabant farm houses.

Y. So everything depends on how a room is articulated?

Z. If a room is well-proportioned, we will find this briefly satisfying, but not in the long run, since that by itself does not make it suitable for "living," that is, for continuous esthetic satisfaction. A room has to be more than an empty space limited by six facing walls. It has to be rather an articulated, *partially filled space with six subdivided planes opposing one another in position, dimension,*

and color. This has always been vaguely felt: the space was divided by furniture and other things; the walls were also somehow divided, not only by the structure itself, but by means of furniture, paintings, etc. Yet all this was done more or less capriciously, and by more or less arbitrary means, so that it became less a matter of articulation, of *expressing relationship,* than of *decoration.*

> **Y.** Certainly.

> **Z.** The design should never revolve around the room's contents. Instead, *everything* should contribute. The various disciplines must not attempt to replace one another. Applied art and painting should not seek to replace architecture, nor conversely. They can only complete the architecture, deepen it in a sense; and architecture can do no more than *support* them. But things have not usually been done this way: architects designed furniture and decorations, while painters attempted architecture facts—decoratively, seeking to emphasize structure by means of ornament, while forgetting that this is the task of architecture. They consequently emphasized the plane in decorative, limiting fashion framing it with border ornament. It is, however *the function of architecture* to *enclose and delimit—although, plastically,* the rectangular plane is expansive in character.

> **Y.** Then architecture itself cannot express expansion?

> **Z.** Although architecture's *structural function*

is space enclosure, it expresses expansion in its own way: *through constructive multiplicity* of its parts and *constructive articulation* of the whole.

 Y. It is now clear to me that decorative painting, expressing itself through *form,* can never adequately express *expansion.*

 Z. Pictorial painting can do this no more than can decorative painting. They are basically the same. So logically, if we purify *both, the two will merge, merge into one.* Once purified, painting works with line and color alone. The painting of the past, whether pictorial or decorative, has always more or less veiled the purely plastic in form and representation. Especially in *representation:* thus some old Moorish ornament is far purer in expression than the "rational" ornament of our modern "stylizing" period and than figurative decoration.

 Y. And is this equally true of the room's *contents:* decorative art, furniture, carpets, and so on?

 Z. Of course. Only in purity can there be *unity.* In the old way, objects dividing the space were conceived not as a means of articulation, but as "things" in their own right, individualistically. They had little really to do with the room's form and color. Because the room was decorated in accord with its principal objects, or the objects were chosen to accord with the decor, a certain "harmony" ensued but no *exact expression of equilibrated*

relationship. The latter requires the equivalence of opposites. If the room is not to be haphazard in character, then neither can its contents be haphazard.

Y. But doesn't the furniture, insofar as it is rectangular, accord with the rectangularity of the room?

Z. To achieve pure equilibrium, the furniture must accord with the total aspect of the room, not only in form, but also with regard to their dimensional and color relationships. In overall shape, naturalistic paintings also correspond to the rectangularity of a room—so long as you disregard what is in them! For a pure articulation of the surface, you would do better to turn them, facing the wall.

Y. So the furniture and everything must be designed in conformity with the room?

Z. Everything should be designed in conformity with *one principle,* that of the *New Plastic,* if pure equilibrated relationship is to be brought to exact expression. Then all the disciplines will automatically collaborate. Each art has its own requirements and needs its own servants. Each requires full study and devotion.

X. The Neo-Plastic room you describe doesn't strike me as very comfortable!

Z. That will depend on how it is realized, and on our personal outlook. What is comfortable for one person is uncomfortable for another. But even taking "comfort" in its deepest sense, the term has lost its usefulness.

X. In sincerity I must say that I do not like your "Neo-Cubist" decoration, although I find the colors quite attractive.

Z. "Neo-Cubist"—that's not a bad description, for the New Plastic is in fact a consequence of Cubism. Cubism is at present more widely known than is the New Plastic, so calling it "Neo-Cubism" might offer a useful clue.

Y. As a layman, I incline to "Neo-Cubism." An artist will of course have a more informed opinion, but the term will do nicely for me!

Now didn't you say that the structure of the room already contributed to your chromoplastic?

Z. To some extent. The loft, the built-in fireplace and closet already give a certain articulation to the interior space and its surfaces. Articulation of planes was also provided by the large skylight above; by the studio window in the front wall, with its major division, in turn subdivided into small panes; by the door and the loft in the back wall; by the chimney and the window in one side wall; and by the large closet in the other. This structural division afforded a basis for the painterly articulation of the walls, the placing of furniture, equipment, and so on.

Y. I see that everything contributes, like those ivory toned curtains now pulled to one side.

Z. They form a rectangular plane that articu-

lates the wall next to the window. To continue that articulation, I applied to the wall the red, the gray, and the white planes. The white shelf with a gray box on it and the white cylindrical jar contribute too.

Y. The jar appears as a rectangular plane!

Z. The gray toolbox in the corner also plays a role.

Y. And the little red-orange paint box below the curtain . . .

Z. seen against the white and the gray plane in the background.

Y. The ivory-painted chair goes well with it.

Z. And close to it the near-white worktable with the cool white jar on one side, and the light red box on the other, contrasting with the black and white planes under the window. And notice next to the worktable, the bench covered in black against the great deep-red plane on the wall near the window.

Y. And the yellow stool handsomely opposes the black bench.

Z. We could go on in the same way through the entire studio. Yet I must repeat: complete unity is still lacking.

Y. Perhaps you mean that the work wall could also have been treated with color. But wouldn't you have found that distracting?

Z. My easel stands in front of the big closet

that advances into the room. The closet could have to be painted a neutral gray, and that problem would be solved . . . No, there is a yet better solution: to cease making separate paintings! If all who agree shaped their rooms along Neo-Plastic lines, we could gradually dispense even with Neo-Plastic painting. Realized "around us," the New Plastic is even more truly alive. To execute a painting or a room: both are equally difficult. It is not enough simply to place a red, a blue, a yellow, or a gray next to each other, for this is still just *decorative.* They must be the *right* red, blue, yellow, gray. Each right in *itself* and *right in mutual relation with the others.* Everything depends on the *how—the how* of position, the *how* of dimension, the *how* of color. And this interaction of color will depend on the structure of the room: the distribution of light will also affect the colors.

 Y. Our rooms generally are far too dark!

 Z. . . . as befits a dark age. But this darkness only points up the need for light; the darkness *around us* relieves the dark *in us;* and thus the light in us develops. Light must enter our rooms, and clarity and color too!

 Y. Is it true, that painting will gradually disappear?

 Z. We will be able to do without abstract-real "painting" as soon as we are able to express its beauty in our surroundings, through the disposition of color in our interiors.

 X. Yet we have never been able to do without

naturalistic painting!

Z. Because it is completely different from abstract-real painting. While mood, naturalistic harmony and so on can be to some extent reflected in our interiors and their contents, it is in naturalistic painting that *individual emotion* finds its most appropriate expression. That is why the past could not dispense with it. Whereas, on the other hand, pure esthetic expression of the universal in determination, exact plastic expression of relationship through color and line alone, these will carry abstract-real painting far beyond painting-in-the-manner-of-nature, even beyond all "painting."

Y. But are an interior and a painting comparable? We perceive a painting all at once in its entirety, for instance, which is not the case with a room.

Z. We also see the room all at once in its entirety, relatively speaking. Remember that inner vision is different from merely optical vision. We move visually through a room and from that we form an inner image—in this way we see all planes as a single plane. Anyhow, is it so desirable to see the expression as an entity? Doesn't the *painting* then remain too much of a "thing" and does not the three-dimensional unity of the wall planes serve to move us multi-dimensionally, i.e., more deeply, more inwardly? I think that precisely in a room the individuality inherent in every expression is more easily annihilated.

X. But a room surrounds us *constantly*. Is it

desirable to constantly live in an environ-
ment of such powerful beauty?

Z. It is with the interior-in-the-manner-of-the-
New Plastic just as it is with painting-in-the-manner-of-the-
New Plastic: both can be seen in a *constant* manner.
Painting-in-the-way-of-nature is predominantly individual and
therefore cannot satisfy us constantly. An esthetic emotion
that is overwhelmingly individual is transitory. Only a *pure
expression* of the universal can satisfy us *constantly.*

Y. Pure expression of *the universal . . .* surely
that also contains deepened individuality.

Z. Yes, for it contains *everything.* Pure plas-
tic expression of the universal is equilibrated. It is thus *the
equilibrated duality of the deepened individual and the
determined universal.*

As against the predominantly individual, against
naturalistic expression, we can also describe the New
Plastic as *plastic expression of the universal.* So the New
Plastic, where individual and universal *oppose each other
in equilibrium* and therefore *in repose* is indeed suited to
surround us constantly. Besides, the New Plastic is so ver-
satile that each room can be shaped in accord with its par-
ticular requirements. The desired harmony of the room and
its intended use are achieved through the relationship and
composition of the color planes, by the extent and intensity
of the color, etc.

Y. Such rooms call for new people!

Z. Someday a new type of people will demand such rooms! Yes, everything depends on people . . . but we will not always remain as we are now: life will *evolve from material-real to abstract-real!*

Y. From what you just said, I see why the New Plastic is so concerned with *equilibrated relationship.* But because it could be objected that a simple esthetic expression of equilibrated relationship is not enough to constitute art, it might be better to speak, say, of esthetic expression of the universal.

Z. Truth has many sides, and we must illuminate as many of them as possible. Your definition is fine, if correctly understood, and the New Plastic often uses it. Yet an improper understanding might cause one to think that in Neo Plasticism the individual is altogether left out. But this is impossible in art. Expression of the universal in determination is unthinkable without the expression of pure equilibrium, and equilibrium is unthinkable without duality. Duality expresses *relationship.* If only one side is expressed, then the particular of whatever kind dominates. To express the universal-in-particularity is to express neither the one nor the other, but equilibrated *relationship* of the two. Thus only the *esthetic expression of equilibrated relationships* alone can contain art, since it contains everything.

Y. Therefore the definition "equilibrated relationship" is indeed well chosen.

Z. And not only for that reason, but also

because the New Plastic focuses attention on the *appearance* of the work. The universal is what one *wants* to express: it *appears* as the equilibrated relationship of opposites. Now that the new is arising, we must first focus attention on its *appearance,* because it is from the *appearance, plastic expression,* that one judges whether a work of art is *in fact* a pure expression of the universal. In art everything depends on *execution,* just as in life everything depends on *action.* In the appearance of the New Plastic, the most exterior means of expression—form and natural color—are deepened, and thus brought into equivalence with pure plastic expression of the inward. These expressive means, the perpendicular color planes, are constantly opposed to one another in a pure way. Thus the New Plastic can speak of equilibrated *relationship,* as opposed to the old painting, which sought to express *harmony.*

 X. But isn't harmony, too, equilibrated relationship?

 Z. Natural harmony, the "old" harmony, is not expressed in accord with the principle of *pure* equilibrium, but only as *relative* equilibrium. It is still dominated by the "repetitiveness" characteristic of nature: it expresses duality but no *constant* annihilation of opposites. Therefore the New Plastic is precisely against the old harmony. It is the difficult task of the new artist to realize the new harmony.

 Y. That is why I will never believe that the Neo-Plastic artist can leave the work's

execution to others, to non-artists.

Z. But what about the architect: doesn't he create art *through the intermediary of others?*

Y. Yes, but architecture is different from painting.

Z. The more painting serves as "the new chromoplastic in architecture," the more it will be able to unite with architecture.

X. But then we will have one less art form!

Z. The time will come when we will be able to dispense with all the arts as we know them: when beauty will have matured into the tangibly real! Mankind will not lose thereby. Architecture will need to change least of all: precisely because it is so different from painting. In architecture the work is already carried out by nonartists who "position" the materials. Why couldn't this be done just as much in painting?

Y. But color is unique!

Z. Just as stone, iron, or wood is "positioned" in architecture, one should be able to place color-panels in painting—if only these existed!

Y. But that wouldn't be the same thing: as soon as one applies color mechanically or causes a nonartist to apply it, that will be something *different.*

Z. It is precisely because in order to create something "different" that the New Plastic seeks a differ-

ent technique. Abstract-real painting already requires a different technique; but the New Chromoplastic in architecture demands much more. You said that the color will be *different;* what you mean is *less precise.* Different, I agree, but, where the New Chromoplastic is concerned, not less precise. For the beauty it will produce will be of a different kind.

X. It will surely be a "colder" beauty.

Z. Colder in respect to individual feeling, but more intense in respect to universal feeling. Because in the New Chromoplastic of architecture so much depends on technique, execution, and materials, it is at present very difficult to give a precise idea of the new beauty, since techniques and materials are still unperfected. The execution demanded by the New Plastic, aided by technicians and machines, will be *different* from direct execution by the artist. But it will be better and closer to his intentions. Today he usually falls short of his intentions. For the artist always has difficulty in making himself a *pure tool* of intuition, of the universal in him. He is constantly to some degree exhausted by technique and execution, and in the process, the universal becomes more or less weakened by his individuality.

X. But isn't the artist's hand everything?

Z. You are still thinking of the old art. Then the artist's hand was indeed everything—precisely because, in the past, individuality played so important a

role. In the old art the universal remained veiled. *The new art demands a new technique.* Exact plastic expression requires *exact* means. And what can be more exact than machine-made materials? The new art needs skilled technicians. The new era is already seeking: there are already colored concrete, colored tiles, *but still useful for the New Plastic.* Until then the New Chromoplastic in architecture will have to be executed by workmen applying "paint."

Y. But wouldn't it become something entirely different, even if the artist were to control the color? A copy of a painting or any art object is always *different* from the original.

Z. That results from the complexity of the technique and the individuality of the artist. Old art objects are often the product of unknown techniques and unfamiliar or aged materials. Nevertheless it is very difficult to distinguish a good copy from the original—to the profit of many dealers! In any case, as I have said the Neo-Plastic artist wants something "different" from what he is already doing.

Y. If the work of art expresses the universal more determinately, and it has become less individual in expression, won't it be easier to copy?

Z. It would be just as difficult, but there would be a better chance of success: precisely because everything is more controllable.

Y. That should make it harder!

Z. At any rate, a copy of a naturalistic paint-

ing would more easily "resemble" some-
thing!

X. But won't the *personal* element in a work
of art disappear when you change the way
it is made?

Z. That is precisely why the New Plastic can
manifest itself as "style." During the great style periods,
"personality" declined, and it was the broad spirit of the
age that powered artistic expression. And that is going on
today. Increasingly the work expresses *itself:* personality is
displaced. *Each work of art* becomes a personality, rather
than each artist. Each work of art becomes a different
expression of *the one.*

X. And in such times, too, didn't Nonartists
also "create" works of art? Wasn't every-
one inspired by the spirit of the age?

Z. Whether the general emotion of beauty
was at work in everyone is difficult to prove or disprove.
But I doubt that the slaves who built the Egyptian pyramids
were much penetrated by the spirit of their age. Yet works
of art were produced that to me are greater than those,
say, of the Middle Ages, when there was already a broader
consciousness of the spirit of the age.

Y. As soon as one becomes more conscious
of the spirit of one's time, then one's personality actually
becomes more clearly pronounced!

Z. Exactly. Then the spirit of the age quickly

becomes part of a person insofar as it has matured in that individual. Then it resumes its universality and "personality" is relegated to the background. The New Plastic makes the personal more and more irrelevant. The more Neo-Plastic painting becomes a reality, and *the more the New Plastic permeates architecture,* then the more will personality fade into the background.

 X. So painting will become what we now call *ornamental art?*

 Z. Only in its technique. In essence; it will by no means be ornamental. Ornamental art *fills, covers, decorates;* but the New Chromoplastic in architecture is *living reality as beauty.*

 Y. And the machine, the mechanically made, and the technicians will become only a *means?*

 Z. Of course. The artist must control everything in order to attain the highest beauty. Yet, as I have said, this does not mean that a non-artist is incapable of creating beauty. He can do so by simply following the basic laws of equilibrium, necessity, and utility.

 Y. And this beauty also arises naturally?

 Z. That depends on the kind of art we mean: a rustic hut is close to nature, a piece of modern engineering is not. In the latter, man is already forced to manifest more or less *equilibrated relationships.*

 Y. Quite true: something of that kind can be

beautiful even though never touched by the hand of an artist.

Z. You see, the artist's hand is not so indispensable!

Y. But what about music? There are instruments, but only an artist can play them!

Z. Again, that is true of the *old* music: the new music makes different demands. The more music becomes pure expression of equilibrated relationships and determinate plastic of the universal, the more it will find itself hampered by existing instruments. Other instruments will be sought—or mechanical means!

Y. As in painting, in order to avoid the individual?

Z. In order to overcome *domination* by the individual. What effort a concert requires on the part of the musicians and the conductor, to avoid slackening the pace. Wouldn't it be fine—and far more reliable—if one could invent a machine to which the real artist, the composer, could entrust his work?

X. But something would be lacking. Think of the violin: the finest new violin does not possess the tone of an old, much-played instrument.

Z. That might be true of the old music. I know nothing of old music and violins, and far prefer the timbre of a jazz band. At least the old harmony has been broken, which is a beginning. The new concert music is

doing the same in its own way.

Y. Since the new beauty is entirely different from that we have known, I feel that art may well need other means and materials.

But . . . we don't just *see;* much reaches us through feeling! Might not the visible act invisibly upon us? I am thinking of a new scientific hypothesis, a theory of ether, claiming that human touch can permanently change matter, depending on the inner state of the person involved. By this hypothesis it would *not* be the same if it is an artist projecting his esthetic emotion onto a canvas or wall, or a workman unthinkingly spreading paint across a surface!

Z. The question depends on whether we can *see* that change in matter. The occultists even say that something of the aura of the person who touches an object lingers around it. If true, this might explain the strange feeling we get in museums of old art: the old aura resisting the new, and conversely. However that may be, inner and outer are closely linked: what seems a "thing" to us is also a force, just as man is another force—and also a thing. Perhaps one force can sense the other. Since we do not know *for sure,* wouldn't we do better to remain with the *certain?* Our senses are attuned to the physical world, not to the ether or the astral plane. Let us confine ourselves to the outwardly visible so long as we have no deeper or other senses. What we cannot perceive is in the realm of

knowledge or feeling. Higher knowledge is relative, and as for individual feeling, only physical sensation can be generally determined. Being determined universal feeling is superior to all other feeling: but it can manifest itself only where particular, individual feelings are not involved. That is why the new art excludes them.

X. So you do not exclude all feeling?

Z. Feeling *changes,* just as beauty changes.

Y. True, our ordinary feelings are far from certain.

Z. Life has only two expressions upon which, aided by pure vision, we can rely: *action* and *plastic manifestation.* We could call pure plastic manifestation a *stilled* action, or stilled outward plastic manifestation, appearance. The latter contains everything and radiates everything, and yet it does not move. It is movement as *purely equilibrated relationship expressing repose.* Both action and plastic manifestation are usually obscured and unclear in life; it is the great task of the new age to make both *shine forth clearly.* In this way *truth* is manifested. Thus truth is the doctrine of the new age, as love was the doctrine of the earlier age. In the past, *love veiled things,* now *love is veiled*—within truth. Love has grown into truth.

Y. Yes, everything is *changing*—yet basically remains the same.

Z. This is the great revolution, the reason why the old age resists the new, and conversely. The old

era seeks—in its fashion—*love,* but not *truth.* And as long as the old prevails, the new, in life as in art, will make only slow progress.

> **Y.** Because for us truth is only what we can perceive, I recognize the importance of plastic appearances.

> **Z.** And the more purely we can see truth, the

more the most external will diminish and the more abstractly we will see and express ourselves plastically.

> **Y.** In this room I can now see the abstract as

a reality. I have the sensation of being surrounded by flowers. Or rather, I experience the beauty of flowers even more strongly than in their actual presence. And that solely through those color planes or, what you would call colored volumes. That little red box reminds me of red poppies in the sun. Now I too can see the New Plastic as the consequence of naturalistic painting. Even the latter sought intensification to a degree. Think of Van Dongen's flowers—just round patches of color.

> **Z.** The abstract beauty that moves you so

deeply here is really the beauty of *all things.* You were thinking of flowers. Good, it is the beauty of flowers, but their deepened, inner *beauty.* Naturalistic flowers are appropriate to children and the female element. Flowers best express the external, the feminine. But here the feminine is expressed in a more inward way and thus is in equivalence with (outwardly viewed) the *spiritual* male ele-

ment that also appears here. *This equilibrated duality forms a true unity . . .* you see how strong the emotion of beauty can be. Color, when internalized, is pure . . . perhaps that is why thought precisely of flowers. But once intensified, *all* natural color is pure, just as all intensified line is *straight,* and all intensified form is *planar.*

Y. Seen in that way, everything becomes much more beautiful . . . and more joyous!

Z. With deepened beauty one can no longer speak of *joy.* Joy is but one side of life's duality: joy and sorrow—plastically manifested as *expansion* and *limitation.* In intensified beauty, the two are equivalently *opposed.* In this way the particularity of *both* joy and grief is annihilated: the outcome is repose. Once beauty is liberated from the dominance of the tragic, one experiences the emotion of freedom, which is joy. . . . To that extent you are right.

Y. And the domination of the tragic is abolished thanks to the annihilation of form?

Z. Because it delimits, form prevents expansion: that is the tragic. Should the limitation now be removed, then the tragic would disappear too, but also everything that manifests itself as real to us. Therefore limitation cannot be entirely eliminated from the plastic, only its *dominating power.* Limitation must be interiorized: form must be tensed to straightness.

Y. And what about expansion?

Z. In form, expansion tends to be expressed vaguely in contrast to the determinateness of limitation. That is why the latter dominates: expansion, plastic manifestation of the life force, must be raised from vagueness to determination if it is to function plastically and in order to equivalently oppose interiorized delimination.

Y. So the New Plastic is the expression of *interiorized limitation and determined expansion?*

Z. Yes. And I already told you that this implies a plastic of the straight and the planar. Only the straight can express *expansion and limitation in equivalence.* The two opposites are plastically manifested through the most extreme difference in position: *the perpendicular.*

Y. And how are expansion and limitation manifested as color?

Z. Through *color relationships,* but also through *color itself.* Just as line needs to be *open* and *straight* in order to express expansion determinately, so must color be *open, pure,* and *clear.* If it is, then it radiates vitality; but if color is closed and confused, then it will obstruct the life force and predominantly express limitation, the tragic. By means of its technique, especially its planarity, the New Plastic can achieve equilibrated expression of opposites in color too.

Y. So what you said about line and color are

general truths . . . strange that they are not generally recognized as such!

Z. That is due to subjective vision: *how* we see line and color, *how* we see expansion and limitation depends on the nature and development of the life force in each of us. On this depends which manifestation we acknowledge as "true."

Y. And we organize our environment in accord with our vision?

Z. Of course. If we are to live in harmony, then our environment must be in accord with our inner life force. In artistic terms: the things that surround us must reflect the character of our life force. For an esthetically oriented person it is as necessary to organize his dwelling or interior in an appropriate manner as it is to eat or drink. For him *the esthetic* is equivalent in value with *the material.* In present society people really think only of the natural, even when they pretend otherwise.

Y. Indeed, everything centers on the physical.

X. How can it be otherwise? The physical is the first necessity.

Z. True. But precisely for this reason man *should be assured of it and not have to concentrate on it so much.* If the material side were more easily satisfied, *it would automatically lose its importance.* In the new society, the material will have to be, as it were, automatically at our disposal—even then it will be no more than in equiv-

alence with our spiritual, our *human* needs.

Y. How is that to be achieved?

Z. First, we must be *strong enough not to regard the material as the most important thing in life . . .* but that requires sacrifice! We must begin by sacrificing ourselves for the ideal of a new society. In *everything* we must begin to *form an image of what must someday be realized in society.* In our discussion I limited myself to the interior but the outdoors is also important.

Y. The outdoor side of our environment is even harder to change, for there we have even less to start from.

Z. It will therefore be a long while before the new is reflected in our cities and streets! Yet their tragic character is to some extent avoidable, even though exterior color is harder to apply and maintain, and in any street the horizontal easily becomes over-dominant. Yet with greater equivalence between the material and the esthetic in a future society, the city could become quite different in appearance and significance.

X. But a city of ancient culture like Paris, for example, how beautiful it is, and how distinguished its overall greyness!

Z. Beautiful indeed. Mature culture has a deep and pronounced beauty. But must *our spirit* cease to develop with the maturation of a single culture? Did not the latter outwardly prepare the way for the new? Must the image of the

new *within* us, like appearances in nature outside *us,* remain forever the same? Man and nature are no longer so closely tied to each other. Isn't it precisely in the city that man has always evolved new forms, and but for financial impediments, even more renewal would have occurred.

Mature culture is beautiful in its perfection. But *perfection* involves death and decay. To oppose decay is therefore a sin against perfection, for it denies a place to the new, to *greater perfection.*

X. You speak most eloquently, but still I fail to see why the mature culture visibly manifested in our great cities has to disappear.

Z. Because this is the matured culture of *form,* which has now come to its end. It is everywhere seen in all its beauty, but at the same time stands in the way of all *that has evolved from this culture of form, namely the clear, pure, and equilibrated expression of expansion and limitation in equivalence announcing a new stage of the human life force.* In this new stage, the city will have to plastically manifest the equivalence *of nature and non-nature as one,* for that is now the content of the life force. This is not achievable by dividing the city into streets and parks, or by filling it with houses, trees, or plantings . . . no, the streets, which is to say groups of buildings, must *themselves* express interiorized nature and externalized spirit in equilibrium.

X. This can concern only your man of the future!

Z. That is precisely why our cities don't yet appear that way.

X. Your views are quite revolutionary!

Z. I repeat: if man seeks to harmonize his environment with his life force, and if that life force becomes deepened, then he will inevitably strive for renewal. And if the duality of that life force becomes more equilibrated, then its expression will be pure equilibrium. When the new man has transformed nature in the image of what he will himself be—*nature and non-nature in equilibrium*—then mankind, including yourselves will have regained paradise on earth!

Y. You show me a vision of joy!

Z. The notion of paradise always evokes joy of living! What I have described is, up to a point, quite achievable. Do not dismiss it as an idle dream. The city of children will someday become the city of adults. We have only to wait for the children to grow up!

Y. If the individual is growing to the universal, this is surely true. I recall a friend of yours who seemed familiar with the New Plastic telling me that in contemplating such work, he felt a *nostalgia for the universal, his deepest being.*

Z. This indicates the nature of the New Plastic, showing that it can strongly and determinately arouse our deepest inwardness. Otherwise the "universal-expressed-in-determination" could not induce nostalgia.

Most people know the universal only as something vague, because of the vagueness in them. They cannot recognize its *pure plastic* manifestation because the universal is not *consciously* present in them. But as soon as we have formed a *determinate image* of the universal in ourselves, we will recognize it in determinate plastic. So you see once again that the spirit of the age through which the universal becomes clear, is showing itself, if only to a few. It is a sign of the new era that we have become so conscious of the universal that we long for its purest manifestation . . . yes, we do yearn for the universal! And this yearning will bring an altogether different art into being.

 Y. I now clearly see the necessity of a new plastic for the new era. But I'd like to return for a moment to what we were saying earlier: that in practice it is hard to achieve harmony between ourselves and our environment!

 Z. Yes, the New Chromoplastic in architecture is still rare. I nevertheless prefer it to the separate Neo-Plastic painting.

 Y. You said that it is more really alive for us?

 Z. Yes, we discussed that. But there is something more: it has the *right* effect regardless of where we stand in the room. A painting, on the other hand, is effective from *one* viewing point only. Especially a Neo-Plastic painting will look wrong unless viewed from the right distance: so precise are its plastic relationships that as soon as we pay any attention to the room, they must be

seen in relation to it. A painting will always have something individual about it. . . . It is, as I said, intended for one person at a time, whereas a room is for many people at the same time: the Neo-Plastic decor is conceived for and in society.

 Y. But what kind of society does it express? I have heard the New Plastic described as "typical expression of the moribund bourgeoisie"!

 Z. That is surprising. The New Plastic especially has nothing of the bourgeois. Are not bourgeois characteristics said to be extreme individualism and a narrow concern for material things?

 X. Precisely because of its attachment to material things, the bourgeoisie desires an art of form.

 Y. And the aristocracy?

 Z. The same is true of the aristocracy, which for the most part equally represents a culture of *materialism.* In rare instances material prosperity enables the aristocrat to transcend the individual. Such a person is truly "an aristocrat of the mind." But normally the aristocracy achieves no more than a certain "refinement" of material life and so clings to a somewhat *"refined"* art of form.

 Y. And the workers? Can we expect a new art from the working class?

 Z. That might once have been possible—in the Middle Ages, for instance. But today, the worker is

engaged in "mass production," as it must be. Such production is guided by intellectuals or artists, and it is from them that we may expect a new art. The worker has become too much of a "machine" and, like the bourgeois and the aristocrat is overly preoccupied with the material side! The New Plastic will have to come from the *new man,* a combination of worker, bourgeois and aristocrat, but quite *different from* them all. Only *he* can realize the new spirit of the age and its beauty: socially as well as plastically.

> **X.** Yet I don't understand why you, who are so concerned with the abstract-real want beauty to be so concrete.
>
> **Z.** As I said, abstract-real life is only a *preparation* for the reshaping of society and of our environment.

X. I understand when you put it that way. But can we expect the inward man to be so concerned with the external? Doesn't he prefer a very austere environment?

Z. The new man is "inward" in a different sense than you think: he too is interiorized *exteriority!* And that other part of him, *the more conscious inward, will cause him to more consciously seek his expression in the outward. The new man will be distinguished precisely by the complete attention to everything external.* He will not rest until the external becomes *pure* expression of the *inner* and *outer* in one.

X. But why do so many "inward" people seem to be without this need?

Z. What I said applies only to the *new man* who has learned to see plastically, who is more *complete.* To be without that need is to be incomplete and one-sided. To be complete is to be *entirely* "true." It means that one's inner and outer lives are in complete equivalence, and thus one. Then the external will be an image of the internal that will be reflected in *all* exteriority. Which is why I find suspect the spirituality of those who today prefer to surround themselves with the capricious, and prefer "capricious" art.

X. The new era is so very demanding and there is so much to consider. Despite its deepening it remains quite outward-oriented.

Z. The new age demands no more than *pure vision.* Its expression reflects the *evolution* of the new man: it shows the stage of inwardness he has attained; it shows that equivalent expression of the inner and the outer marks the stage of greater equilibrium . . . and what do we seek more than *equilibrium?* The old era, the old art, sought equilibrium through *form* . . . but isn't form even more external? All the suffering of all the artists of the past can be attributed to the impossibility of rendering inwardness in *form,* for lack of a pure expression.

X. But is that really what they wanted?

Z. *Unconsciously,* yes. This is what intuition, the well-spring of art, always wants.

Y. Then the suffering of an artist who works without form will be less?

Z. Less, but he still suffers, because he too is bound to an outward expression, even if a deepened one. An artist will always suffer because he too is still externality, no matter how interiorized! He suffers because he always remains only part of a whole. He suffers in the plastic as well as the social spheres because the majority lags behind. He is compelled to live amid the art of others and forced to participate in the injustices of our present society. There will always be suffering, for even in the New Plastic the universal cannot be expressed in total purity. There will also be suffering because so much of the new has yet to be realized. But the suffering will decrease in the measure that equilibrium is established between inner and outer, and man becomes more *complete. The life force manifests itself ever more freely purely and deeply.*

Y. Equilibrium between inner and outer: yes, *that* is what we must find. We are inclined to perceive everything externally, and that determines our perception of the life force.

Z. Or only *inwardly,* which is just as dangerous as long as we are not complete.

Y. If we contemplate everything from the most outward viewpoint, then the most powerful representation of the outward just-as-it-appears-to-us would strike us as the most powerful representation of the life force.

Z. And if we behold the life force inwardly, then we may still conceive it wrongly . . . again because of the most outward.

Y. So our inwardness and our exteriority must indeed become wholly one if we are to recognize the life force in its purest expression?

Z. Fortunately we can do this before achieving complete unity: Fortunately, contemporary man despite his insufficiency, can intuit the greater perfection of the new spirit. That is why, despite our deficiencies, the New Plastic could already come into being as esthetic expression of the new spirit.

Y. The majority does not see the New Plastic as pure manifestation of the life force. I have even heard it described as "antiseptic" or "clinical" art!

Z. From their point of view, they're right. Children are not to blame for failing to understand an adult expression of vitality.

Y. Yes the life forces of the old and of the new man are totally different!

Z. The vitality of the new man can be called *conscious radiation of the universal.* Generally, it appears as wisdom rather than joy. It is, however, all these in one. In art it can be said to appear as esthetic expression of pure equilibrium as pure expression of repose, even if this definition fails to mention its richness combined with simplicity, as well as so much else.

Y. Although the new era has *grown* out of the old, the two are absolutely different.

Z. Evolution—and mutation—demonstrate this: *externally, evolution prepares a new form, but in mutation the new appears suddenly, as something entirely different.*

Y. The old and the new man live in distinct spheres.

Z. The old era and the new differ in that the first always wants and seeks the tragic. In art, too, the old era is at home with the tragic, the lyric, the sentimental.

Y. Due to the domination of the natural?

Z. Right. And it is noteworthy that the old increasingly resists the new, as the new frees itself of the old. We *see* this in the fact that the New Plastic is increasingly resisted as it discards the tragic, the lyric, and the sentimental.

Y. The new era leaves such things far behind!

Z. . . . Because the individual has matured into the universal: The new man can live only in the sphere of the universal.

Y. While in this same sphere the man of the old era will feel frozen and ill at ease.

Z. So we see the *complete* difference between the old and the new eras. The new era is a higher stage of the one, single life force.

Y. I now understand that plastic expression of our life force, the art expression, must constantly become "different."

Z. Through growth everything changes. Man grows beyond *nature:* thus the plastic expression of his life force will perforce be different. He followed nature only so long as the spirit of the age was predominantly natural. Now that the natural in him has matured, he can no longer be satisfied with naturalistic representation of the life force. Now *his more complete, human consciousness demands a different representation.*

TWO URBAN SKETCHES

"Les Grands Boulevards" and
"Little Restaurant—Palm Sunday"

His sole attempts to apply Neo-Plastic principles to literary art, these delightful pieces tell of Mondrian's fascination with the competing stimuli and relationships of the metropolis. The static repose of rural nature that marked his early painting is now supplanted by the dynamic equilibrium of the metropolis, the abstract-real home of the modern man.

The disjunctive, stream-of-consciousness technique attests to Mondrian's admiration for Cubism and Futurism for destroying the separateness of the object, which they merged with its surroundings. Echoed here is the Futurists' interest in pansensory experience: the simultaneous impact of sights, sounds, and movement in the multifarious urban scene.

Reflecting at once the idealist and the empiricist sides of his character, Mondrian's experiment combines outward description with a tendency to the contemplative and symbolic, if not moralistic.

As always, Mondrian sees in terms of opposing dualities and their resultant unity. Spiritual and sensory, type and individual, arrest and movement, all are sublimated within the multiplicity of urban life.

–Martin S. James

LES GRANDS BOULEVARDS

Ru-h ru-h-h-h-h-h. Poeoeoe. Tik-tik-tik-tik. Pre. R-r-r-r-r-uh-h. Huh! Pang. Su-su-su-su-ur. Boe-a-ah. R-r-r-r. Foeh . . . a multiplicity of sounds, interpenetrating. Automobiles, buses, carts, cabs, people, lampposts, trees . . . all mixed; against cafés, shops, offices, posters, display windows: a multiplicity of things. Movement and standstill: diverse motions. Movement in space and movement in time. Manifold images and manifold thoughts.

Images are veiled truths. Manifold truths make truth. Particularity cannot describe everything in a single image. Parisiennes: refined sensuality. Internalized outwardness. Tensed naturalness. Was Margaret[1] like that? Yet Margaret went to heaven. But was it through her outwardness?

Ru-ru-ru-u-u. Pre. . . . Images are limitations. Multiple images and manifold limitations. Annihilation of images and limitations through manifold images. Limitations veil truth. Riddle: where is truth in truth? Limitations are as relative as images and as time and space. After today there will be other days and images, and this boulevard is not the only boulevard. Days form centuries, and the airplane has abolished distance. Time and space move: the relative moves and what moves is relative. Parisian: fashion transforms the boulevard from year

to year. Every age has its expression. Although a man is still a man and art is still art—I see the expression of art changing. What is temporal moves; what moves is temporal. Separation is painful. The moving moves and changes with motion, in time. Displays change more rapidly than shops, and I see architecture lagging behind. Why is a stone so hard and a purse so small? Yet even immobility varies for the man in the car and the slow pedestrian. Even immobility is relative. Everything on the boulevard moves. To move: to create and to annihilate. Everyone creates— who dares annihilate himself again and again? On the boulevard one thing annihilates the other, visually. In fast and in slow tempo. Rapid change of particularity breaks the sensual tension. Relationship is through multiplicity. Rapid motion breaks the unity of masses and all distinctness. To annihilate the particular is to achieve unity, say the philosophers.

Negro head, widow's veil, Parisienne's shoes, soldier's legs, cart wheel, Parisienne's ankles, piece of pavement, part of a fat man, walking-stick nob, piece of newspaper, lamp post base, red feather. . . . I see only *fragments* of the particular. Together they compose another reality that confounds our habitual conception of reality. Together these parts form a unity of broken images, automatically perceived. A Parisienne. Does everyone see "broken" images, and does everyone grasp fragments "automatically"? *Plastically* seen, everything fuses into a single

image of color and form. An image images something: color and form alone image something—what? Where is truth in truth? The particular disappears *in the plastic image*; does it in society too? The plastic image can be a bit ahead of us. A student is waiting for a girl. A long wait. Time passes slowly. How fast that car's wheel is turning. Is it round in order to turn or does it turn because it is round? There is round and there is straight on the boulevard, in movement. Money is round and the earth is round. Round too was the serpent in Paradise. The table top before me is round, but I don't see it turning. The auto wheel is round, and the *spokes in it* are straight. The straight *in* the round.

Everywhere? The round moves the straight, the straight moves the round. The outward and the inward: both are necessary. The wheel turns fast: I do not *see* the spokes. Nor do I see the motor that moves the car. The wheel moves and its hub stands still. Is the hub motionless then? Is the most inward, seen from without, always still? *Souscrivez à l'Emprunt de la Paix*: [Buy Peace Bonds!] In red and blue and white. War-Peace. Is the outward ever still? Ruh! ru-ru-h-h. There is stillness in the desert—so long as we are not in it. Multiplicity of sounds is the annihilation of sounds and thoughts.

Poeoe-pang . . . one sound breaks the other. A new harmony arises. Sound is motion: sounds change in space and time. Beggar. Owners. Owners, small and big. Without ownership there is no movement; no ownership without

movement. Everything owns, everything moves. Diverse movement, diverse ownership.—Who owns not moves not but is moved. Who is moved does not own. The lamp post is a king—it stands still (for the moment at least)! A Parisienne. The outward is ahead of the inward on the boulevard. But not everywhere.

Nevertheless the one is the other. The policeman at the intersection imposes order. Poeh-oeh-h. Puh! The cars too. The policeman is no Mengelberg[2] but he conducts. "A concert," as a friend of mine said. Without the musical instruments, my grocer says it is no concert. Raymond Duncan[3] tries to create rhythm and so does Dalcroze.[4] Dalcroze starts from music and Duncan from handicraft. Can there be handicraft, after the boulevard? Duncan is far ahead of the boulevard—if you are looking backward. Pretty shoes; black patent leather; gray stitching. Gray stockings. Parisienne. Duncan wants neither shoes nor stockings. Yet the policeman, Raymond Duncan, Dalcroze, the automobile, and an engineer, and the Parisienne all are doing the same thing: creating rhythm. *Un cassis à l'eau, un Turin à l'eau. . . .* People drink alike, but not the same things. The sidewalk under the awning is a refuge. The sidewalk—under the awning or not—the car, the policeman, all organize outward rhythm. Who organizes inward rhythm? If only one were always equal to another? Is the stroller moved or is *he* the mover? The artist *causes* to move and *is moved*. He is policeman, automobile, all in

one. He who creates motion also creates rest.

What is brought to rest aesthetically is art. Rest is necessity, art is necessity. Hence dilettantism. Movement is a necessity. Hence the boulevard and art too. That child over there is watching the boulevard. I too am watching. Parisienne. She would not be at home in the desert. One belongs to the other. Why can one never leave one's "own kind"? Is that why it is so hard to find one's "own kind"? Parisienne. Officer. Captain. Parisienne. Parisienne alone. Two Parisiennes alone. Why is the foreigner sitting there alone? Flowers and vendor. The flowers on that hat are another kind. Picture postcards, plans of Paris. Many foreigners on the boulevard. The boulevard is international. Language not yet. Language lags far behind, in much it is ahead. In literature: why must one always *describe* and *circum*scribe? A Negro—the boulevard is international. Not all internationals understand one another. There are many religions at the same time. There is one fashion at a time. Parisiennes—one is like another in face and dress. An unconscious chastity: With color, the face is covered. Did Margaret do this? Particular preference persists. Particular preference is pleasant for the chooser and the chosen and unpleasant to others—like personal property. A rich man. I see no thief. Thief and rich man both want individual possessions. The artist gives the universal universality. What is here on display is more universally wanted. Everything here is *real*: art often is not. Everything here on the boule-

vard is of actual importance, everything here is necessity. Luxury too is necessity. The baker thinks it's a shame the state has doubled the price of bread but not admission to dance halls. He does not yet understand movement as a whole: he does not understand the boulevard. The boulevard is the movement of the cultivated. The movement of fancy rolls is something else again. Perhaps he is secretly taking lessons from Raymond Duncan and hates the tango. Huh-huh! The particular carries me away: that is the boulevard. Now I see a woman in a donkey cart. One cannot always see everything in its wholeness—or shall I see particularities too "as a whole"? Then at least I cannot see the woman and the car as foreign to the boulevard. Tugboats go slowly. Tradition is strong and not all purses are equally big. The captain. His head is still a soldier's but dress has changed since the war. I have just read that the local undertakers are demanding a costume more in keeping with the times. Nature is more perfect than the human spirit. *Paris Sport! La Presse!* Man works upon nature and spirit. My table is getting wet, it is raining. It is not raining in the church. The boulevard is open, the church is closed. Is that why it is so cold in the church? At a recent exhibition of paintings in the Grand Palais it was just as cold. In the Métro people are a bit too warm, however. *L'Intransigeant, La Liberté, Le Populaire.* A different sound than *Les Rameaux* [Psalms] or *Réveillon* [Christmas Eve]. The Kaleidoscope shows us the most diverse things.

But *au fond* is everything so different? Or in time does one thing become the other? On the boulevard one thing follows another but yet they dissolve into one another. A quiet moonlight night makes everything possible. Toot, toot. So can the automobile (on the inside). Seen from the outside on the boulevard, it is part of the whole. Ru-huh! The boulevard! What always draws me to the particular? The boulevard is more concentrated! I see the colors and form, I hear the noises, I feel the warmth of spring, I smell the spring air, the gasoline, the perfumes—I taste the coffee. The boulevard is the physical turning outward and the spiritual turning inward. The spiritual sublimates the physical, the physical sublimates the spirit. *Trois cafés!* Who sublimates, sublimates everywhere, and who drinks coffee alone on the boulevard drinks coffee alone in the country. One coffee and another are both coffee, but the boulevard and the outdoors are not identical. Ruh-ruhh-r-r-r. The Cubist on the boulevard. Courbet in his studio[5] and Corot in a landscape . . . everything in its place. Place transforms man and man transforms nature. Hence the word "art." On the boulevard there is already much "artifice," but it is not yet "art."

NOTES

[1] Presumably, Margaret in Goethe's *Faust*. Mondrian, like Goethe, calls her Gretchen.

[2] The celebrated conductor J.W. Mengelberg (1871–1951) led the orchestra of the Amsterdam Concertgebouw from 1895 to 1945.

[3] Isadora Duncan's brother Raymond (1874–1966) lectured widely on the arts (and practiced several of them), advocating self-sufficiency through the handicrafts. He was often seen in Paris and New York, dressed in a Grecian manner.

[4] Emile Jaques-Dalcroze (1865–1950), Swiss composer and educator, created Eurythmics, in which a sense of rhythm was developed by translating music into bodily movement.

[5] Mondrian had written to Van Doesburg on 4 December 1919: "I went [to the Louvre] to see Courbet's famous *Atelier*. Of course it is good, but not good in the way a Rembrandt is *good*."

LITTLE RESTAURANT
—PALM SUNDAY

Chairs, yellow and blue. White-decked tables—carafes—blue siphons—people, under the terrace awning and indoors. The glass wall open: the little restaurant opens itself to the sun. The whole framed by evergreens in boxes that also are green. Inside and outside: the owners and the people asking for an eight-hour day or night (says *L'Intran* in my hands). Workman and intellectual. A family. "Sunday best." I think of "Sunday" in the provinces. A Parisienne. "*Une banane.*" "*Une chopine de rouge*" [a pint of red wine]. "*Une religieuse.*" "*Quatre sous de pain.*" Worse bread, higher priced, *after* the war. Behind the evergreens on the sidewalk, people to the right and people to the left. Most to the right. "*Voici, monsieur.*" "*Merci, mademoiselle.*" On the right the Métro and also the Barrière [city gate]. The Barrière leads out and the Métro leads in. Left are the church of Montrouge and the city. For a long time Montrouge was beyond the Barrière. Bing-bang—bing—bang—Montrouge church is still where it was. Black silhouettes behind the green shrubs. The sun shines equally on the dark figures of people—darker on Sunday than on other days—and on the white tables—whiter on Sunday than on other days. On working days it is quite different at this hour. An hour later: different again. No people: the chairs, the

tables, the carafes, the siphons are again "themselves." Who is "himself"? Pang. A glass of wine knocked over. Who experiences everything and stays unchanged? In winter the restaurant is different again. The lace curtain in front of the glass wall refines what is outside: tnar—uats—er, gigantic letters on the three glass panels above the white. The words tell their meaning on the outside: restaurant. The ornament on the white below has no special meaning. It is what it is, from both inside and out. "*Une pomme purée.*" A beggar. He is *dans la purée* [in the soup]. "Un mendiant" [a dessert, a beggar]. Better to eat a "mendiant" than to be one. Union Centrale—an archway—des Grandes Marques. The great factory gate across the way is closed on Sunday. On Sunday, who is "open"? A woman trolley conductor. The green shrubs leave an opening. Two soldiers. Everything has its "sphere." Restaurant, things, and men. One thing is at the expense of another. "*Dix sous la botte, pas cher!*" [Ten sous a bunch, cheap!] Flowers on the pushcarts by the sidewalk. Carts with apples. Carts with oranges. Carts everywhere. "*Caisse*" [cashier]. The "*caisse*" is still operating—thanks to money. Heads and hats above the evergreens. Evergreens about as tall as the normal man. What is normal? "*Un bifteck aux pommes.*" Who is normal? The French are not tall: in England the hedge would have to be taller. That soldier over there comes above it, so does that lady and so does that priest. A little man with a stiff leg is near me. An abnormal foot. Among the normal, the abnor-

mal. What is abnormal? A young woman with a pointed hat. Abnormal only "here." The crowd decides. But the taller person can see more. A car on the left, a perambulator to the right. Both reach their destination. The evergreens in boxes: neither to the left nor to the right on Palm Sunday. Straight up. The green shrubs are not palms. Today sprigs of boxwood [buis] serve as palms. The *buis* is blessed by the church. The shrubs, to what blessing do they owe their blessing? Re-re-re-re—t-toe-oeh! There is a particular blessing in the green of the shrubs. These chairs, these tables, these dishes, these people—who blesses them? Three men with palms. The flower vendor also has palms. A widow, a child, a decorated soldier, all with palms. How did the soldier earn his palm? A poet without a palm. Two ladies with palms and parasols. People like to protect themselves. Two, three, four young girls with palms. The dove of the Ark carried such a green branch. "*Merci, madame.*" "*L'addition, s'il vous plaît.*" Montrouge—Gare de l'est— Gare de l'est—Montrouge in red on yellow. Coming and going. Ebb and flow. Both the trams alike but their content is different. Outside, a child is spelling: A-lec-san-dre. From the inside, I see erdnaxela on the flap of the awning against the light. But is not Hebrew. alexandre reversed. The word is changed but some of the letters remain unchanged. Who is the same from the inside and from the outside? And yet each letter remains itself: inside and outside are one. Yet the outward remains the inward—the outward is made up

of the inward and the inward of the outward. But the outer side seems to be the one we understand first. "Une orange." Orange outside and orange inside. The orange from outside is other than the orange from inside. "Un petit suise." Equally white outside and inside. "Violà, monsieur." Orange on the white plate on the white napkin. Purity through one color and purity through fullness of colors. Purity by reflection and purity by absorption. Who absorbs *purely* and reflects *purely*? The orange is a feast in the sun. Yet sometimes one is afraid of pure color. White envelope on white napkin. 10 cts. A deaf-mute through the green shrub. Pink paper: *Horoscope*. Re-re-re-re-h-h—*Montrouge—St. Augustin* in red on yellow. The deaf-mute hears no noise from outside. Does he hear from within? "*Du pain, s'il vous plaît.*" "*Merci, madame.*" Everyone talks. They hear noises from outside—is that why they speak? The deaf-mute can see well enough. Does he see more? Rhoe-aeh-hae! This automobile he does not see. "*Qu'est-ce que vous prenez, madame?*" The *fille de salle* is not deaf-mute. The orange was deaf-mute. Which "speaks" most? My *boeuf bourguignon* was also deaf-mute. Yet it too "spoke." But differently. The orange was orange and the beef was brown. I would not have liked either the other way round. "*Une blanquette de veau!*" Each thing according to its nature. Everything is good if "the kind" is good. Yet each thing and each kind is capable of improvement—but then doesn't it cease to be "of its kind"? The beef was "beef" and the

orange was "orange"—who is actually what he is named? The orange is no good before it is ripe, nor the beef before it is ready. When are we ripe and ready? Beef is beef and orange is orange. A gourmet is a gourmet even in the church of Montrouge. Yet a businessman is often a man of very little business and an artist is often very little an artist. A man is sometimes a woman and a woman sometimes no woman. "*Un boeuf gros sel.*" "*Une pomme dessert.*" The coarse and the fine. Both are necessary. Can they take each other's place? Each costs money: each has value. "*Elle n'est pas très bonne,*" the apple is of little value, yet it costs money. "*Deux cafés, deux!*" I see the pink paper again. *Horoscope* . . . a legacy; but the horoscope is for a woman, not for me. An automobile. A Sunday hat blows off. I feel the wind along the glass screen behind me. The sun is shining and the wind is cold. The good and the bad together. The sun is shining on the flower carts, on the *oranges*, on the avenue. A poster across the way: *Fabrique de sommiers.* The factory is necessary like the restaurant. Behind me, through the glass, a bit of the fortifications—posters in front. Behind the fortifications *apaches* are asleep on the grass. But one is not yet out of the city. *Apache*, city, police: each exists through the others. The avenue runs on beyond the Barrière. At night, no individuals. Only the crowd is moving but the avenue is alive. A freight train is running on the trolley rails: with produce. Without provisions, no city, no restaurant. Everything is

linked. But the link "between pig and tong" is hard to find. *"Un café vieux marc."* This workman does not permit himself any luxury: liqueur neutralizes wine. The young woman puts water in her wine. The man does not put water in his wine, yet takes no liqueur. The pharmacy still has *charbon naphtolé granulé* and *vin de Pepsine Byla.* Everything has a remedy and each remedy has its disease. Buttermilk helps one's stomach too. Where there is nothing, even the king has no rights: there is no buttermilk in Paris. *"Dix sous la botte."* The flower seller doesn't water her wine but her flowers in the sun. Her flowers come from outside Paris and so does she. So does the little woman with the *coeurs à la crème.* She has lunch and does business with the restaurant. A *coeur à la crème*: a heart of buttermilk in milk. White in white and yet not the same. Buttermilk in Paris! We find the same thing everywhere in different form. Many *coeurs à la crème* take the place of liqueurs and medicines. The liqueurs and the medicines in turn replace many "hearts." *"Je vous donne mon coeur"*—she has many of them, *la bonne femme. "Ma fille!* . . . At one time she had just one heart. The couple over there are sharing one *coeur à la crème.* This *petit trottin* [messenger boy] has two *coeurs à la crème.* The foreigner over there is eating his *coeur à la crème* alone. A soldier. Has he a *coeur à la crème*? A *coeur à la crème* is not only soft but also white. *"Vous avez terminé, monsieur?"*

CHRONOLOGY

1869
Marriage of Piet Mondriaan's future parents. His father, Pieter Cornelis Mondriaan Sr. (1839–1921) is appointed principal of a Protestant primary school in Amersfoort.

1872
Birth of Pieter Cornelis Mondriaan Jr. (Piet Mondriaan), one of five children.

1880
Father appointed to a school in Winterswijk, eastern Netherlands, which Piet attends.
At an early age, assists his father in execution of patriotic commemmorative prints reflecting the latter's conservative, orthodox Calvinist outlook.

1886
His primary education over, at 14 studies at home for license to teach drawing on the primary level (obtained the following year).

1889
As a youth, is often taken on painting trips by his uncle Frits Mondriaan (1853–1932), later a professional artist. Piet's early landscapes are almost indistinguishable from his uncle's.

1892
Licensed to teach drawing on the secondary level.

In Amsterdam, begins two years of study at the state Academy. His work is judged "good" or "fair." Begins exhibiting with various art associations.

1894–97
Continues at the Academy in evening drawing classes. Supports himself by doing still-lives, portraits, landscapes, copies, and by giving art lessons.

Ca 1895–1905: "Naturalistic" phase.
Landscapes in Dutch impressionist manner. Portraits, still-lives etc.

Ca. 1901: For several years paints along river Gein, on outskirts of Amsterdam.

1904: Brabant: farm scenes, interiors, windmills.

1898
Unsuccessful in Prix de Rome competition (figure painting).

ca. 1900
Begins lifelong friendship with Albert van den Briel, a forester, who shares his interest in Theosophy.

1904
Critical of society, spends year in a Brabant village, where he admires the faith and simplicity of farming people.

1905
Influential van Gogh exhibition at Stedelijk Museum, Amsterdam.

1906
[Paris: Fauves at Salon d'Automne.]

1906–07: Period of the "Evening Landscapes"
Moonlit scenes with water, dark tree-clumps, reflections in water. Symbolist feeling. Broader brushwork and unusual color effects.

Often works in Oele, eastern Netherlands.

1907
Association with fauve-influenced Jan Sluyters.
Fall: Modernist work by Kees van Dongen, Sluyters, and others is shown in Amsterdam.

1908
An exhibition of "Luminist" work by Sluyters, Jan Toorop, and Mondrian marks the advent of Dutch modernism.
Begins visits to Domburg, seaside art colony on low-lying isle of Walcheren.

1908–11: Luminist or Zeeland Period.
Fauvist and divisionist influence.

Paints in vicinity of Domburg where buildings loom above expansive flatness. Subjects: church, light-towers, windmill, sea and dunes.

1909
(January) Joint exhibition with Sluyters places him in the forefront of the Dutch avant-garde.
(May) Enrolls in Dutch Theosophical Society.
Explains to a critic the spiritual aims of recent female portrait.
Continues visits to Domburg.

1910
(December) On committee of new Modern Art Circle
(Moderne Kunstkring).

1910–11 Geometric Stylization in triangular planes
Sense of monumental scale, "exaggerated" color.
Windmill; dunes.

The triptych *Evolution* is unique in its explicit
Theosophical symbolism.

1911
(October) In the group's first exhibition, encounters early
Cubist painting of Picasso and Braque. Among his own
entries is the triptych *Evolution*.

1912
(Spring) Moves to Paris. In France will spell his name
Mondrian.
(Summer) Domburg.

1912–14: Cubist phases (Paris)
1912–13: "Compositions" in ochres, browns and
greys, most often based on drawings of trees.

1913–14: Compositions typically based on studies
of party-walls with rectangular traces of demolished
rooms. Accentuation and opposition of line and
color, and between straight and curved elements.

1913
His article on art and theosophy is rejected by the Dutch
theosophical journal.

1914
(August) World War I breaks out during summer visit to Holland.
His stay will last to June 1919.

1914–16: "Plus-minus" phase (begun in Paris, continued in Holland)
All lines eventually "taughtened" to straightness, and the oblique eliminated in favor of horizontal-vertical oppositions. Combination of symmetry and randomness.

Church façades (Paris). Breakwaters and ocean.

Composition 1916 (S.R. Guggenheim Museum, N.Y.): the picture is mounted "in front of the frame."

1915
Settles in Laren near Amsterdam. Meets Salomon Slijper, a business man, who becomes his leading collector; the modernist composer van Domselaer; and the esoteric philosopher M.H.J. Schoenmaekers. Begins writing a "book."
(October) One of Mondrian's "plus-minus" compositions is lauded by the artist-writer Theo van Doesburg, who proposes a periodical devoted to the new art and thought.

1916
(Spring) The painter Bart van der Leck (1876–1958) settles in Laren. Close exchange of ideas with Mondrian. Van der Leck's stylized renderings of social themes are painted in very flat planes of primary color.

In 1915–16 Mondrian completes little work, given the exigencies of writing and copying in museums. For some years his situation is eased by stipend from Kröller-Müller family (in return for works now in museum of that name).

1917
(October) Van Doesburg brings out first issue of monthly *De Stijl* ([The] Style).
Mondrian's "book," *The New Plastic in Painting*, is serialized over the periodical's first year.

1917–44: The Neo-Plastic Phases
Composition in Line (1917) was begun the previous year in the "plus-minus" manner. Influenced by van der Leck's technique, Mondrian broadened the thin lines into rectangular planes on white ground.

1918–19: Grid and checkerboard compositions.
Invention of the "diamond" format.

1919
(February) Completes *Dialogue on the New Plastic*.
(June) The *Trialogue* begins serialization in *De Stijl* (through August 1920).
(June) Returns to Paris.
(November) Moves to rue de Coulmiers studio, prototype of the Abstract-Real painter's studio described in *Trialogue* scene 7 (published March–August 1920).

1920
(Spring) Van Doesburg, in Paris, encourages Mondrian to write "Les Grands Boulevards," published in Dutch newspaper. In consultation with Mondrian, he drafts *De Stijl* manifesto on literature, influenced by Futurism and Dada.
In *Le Néo-Plasticisme: Principe général de l'équivalence*

plastique, Mondrian applies his principles to music, litera-
ture, sculpture, and architecture.
(October) Moves to studio on rue du Départ, which he also
articulates along Neo-Plastic lines.

1920: Early Classic phase: Planes of red, yellow,
blue and grey are divided by grey lines.

1922
A retrospective at Amsterdam Stedelijk Museum honors
his 50th birthday.

1923
Van Doesburg and others show De Stijl architecture at
Galerie de l'Effort Moderne.

ca. 1923 on: Classic Neo-Plasticism.
In course of the 20s grey planes give way to white,
colors become primary, and compositions more
open.

Until the late 20s, Mondrian is obliged to earn
money by painting watercolors of flowers (cf.
Dialogue).

c. 1932: Introduction of the "double line" makes
for more dynamic rhythm.
In course of the 30s the format is increasingly
crossed by multiple continuous lines which create
varying densities.

1924
Van Doesburg (Elementarism; counter-construction)
replaces Mondrian's principle of horizontal-vertical opposi-
tion with that of the oblique versus the horizontal-vertical

(the human vs. the natural). Mondrian ceases to publish in *De Stijl*.

1925–26
(Germany) The Bauhaus publishes several of Mondrian's essays.
Exhibition at a Dresden gallery. Commission to design living room for a Dresden patron.
Around this time some Swiss and American collectors also become interested in his work.

1927
Personal break with Van Doesburg, who called Neo-Plasticism static and "classical" in contrast to his own Elementarism.

1930
Begins exhibiting with broad abstract group Cercle et Carré.
The depression reverses economic gains.

1931
Van Doesburg dies at 47.

c. 1934
Mondrian's reputation growing in U.S., e.g. Museum of Modern Art's *Cubism and Abstract Art* (1936).

1938
(September) Fear of Nazi war (Munich Pact) drives him to London.

1940
(October) Arrives in New York, having experienced the London Blitz.

1941–44: The New York Paintings
Mondrian enlivens compositions begun in Europe with small color planes unconfined by black lines.

The availability of colored tape encourages his abandonment of the black line in favor of criss-crossing and overlapping colored bands.

His last, "boogie-woogie" canvases depart still further from his norm. In their multiplicity they recall his earlier grid and checkerboard paintings, and his enthusiasm for urban life.

1942
(January–February) One man show at Dudensing Gallery, accompanied by his autobiographical sketch *Toward the True Vision of Reality*.

1943
(March–April) Second show at Dudensing includes *Broadway Boogie-Woogie*, which is acquired by the Museum of Modern Art.
(October) Moves into a new studio, promptly transforming it with colored cards and furniture improvised from scrap materials.

1944
(February 1) Dies of pneumonia aged 72. A retrospective planned by the Museum of Modern Art takes place in 1945.

BIBLIOGRAPHY

1—*Mondrian: Life and Work*
Blotkamp, Carel. *Mondrian: The Art of Destruction*. London: Reaktion Books, 1944.

Champa, Kermit. *Mondrian Studies*. Chicago: University of Chicago Press, 1985.

Jaffé, H.L.C. *Piet Mondrian*. New York: Harry N. Abrams, 1970.

Milner, John. *Mondrian*. London: Phaedon Press, 1992.

New York: S.R. Guggenheim Museum; *Piet Mondrian Centennial Exhibition*, 1971.

Seuphor, Michel. *Piet Mondrian: Life and Work*. New York: Harry N. Abrams, 1956.

Stuttgart: Staatsgalerie Stuttgart. *Mondrian: Drawings, Watercolors, New York Paintings*, 1980.

2—*Mondrian as Writer.*
Blotkamp, Carel: *Mondrian: The Art of Destruction* (as above), [Chapter 3 discusses the Dialogue and Trialogue, and the Paris sketches.]

Harry Holtzman and Martin James, eds., *The New Art—The New Life: The Collected Writings of Piet Mondrian*. Boston: G.K. Hall, 1986; New York: Da Capo Press, 1993.) [All Mondrian's writings for publication, and their background; also some early letters. Chronology and bibliography.]

3—Architecture, Theo van Doesburg and De Stijl.
Baljeu, Joost. *Theo van Doesburg.* New York: MacMillan, 1984.

Jaffé, H.L.C.. *De Stijl.* New York: Harry N. Abrams [1971].

Minneapolis: Walker Art Center. *De Stijl 1971–1931: Visions of Utopia.* Ed. Mildred Friedman, 1982.

Overy, Paul. *De Stijl.* London: Thames and Hudson, 1991.

Troy, Nancy J. *The De Stijl Environment.* Cambridge: MIT Press, 1983.

4—Mondrian and Theosophy:
Blotkamp, Carel. "Annunciation of the New Mysticism: Dutch Symbolism and Early Abstraction," in: Los Angeles County Museum of Art, *The Spiritual in Art: Abstract Painting 1890–1985.*

Welsh, R.P. "Mondrian and Theosophy," in New York: S.R. Guggenheim Museum (as above).